IMAGES
of America

ITALIANS IN DETROIT

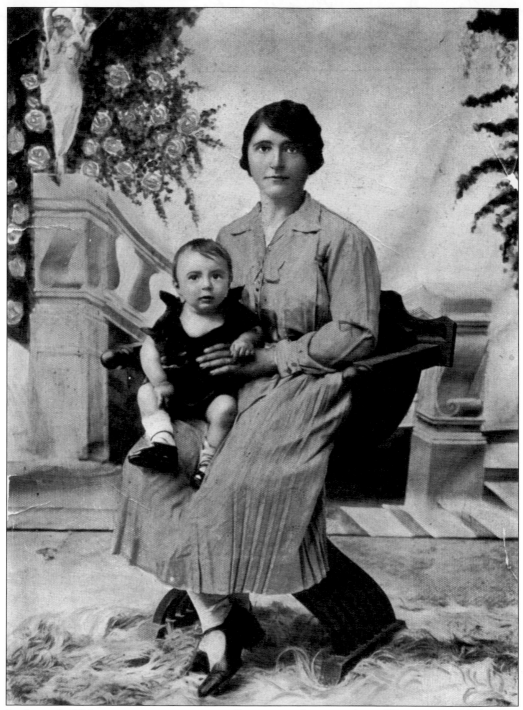

In the early 20th century, young men usually came to America alone. Their wives and children often spent years waiting for them to return or to ask that they join them in America. This photograph was made so that Giovanna Delicato and her infant daughter Antoinette's father would remember them during their separation. One of the biggest sacrifices that the early immigrants made was the separation from their loved ones.

IMAGES
of America

ITALIANS IN DETROIT

Armando Delicato

ARCADIA
PUBLISHING

Published by Arcadia Publishing
Charleston SC, Chicago IL, Portsmouth NH, San Francisco CA

Printed in the United States of America

Library of Congress Catalog Card Number: 2005930282

For all general information contact Arcadia Publishing at:
Telephone 843-853-2070
Fax 843-853-0044
E-mail sales@arcadiapublishing.com
For customer service and orders:
Toll-Free 1-888-313-2665

Visit us on the Internet at www.arcadiapublishing.com

I dedicate this book to my wife, Connie.

CONTENTS

Acknowledgments 6

Introduction 7

1. Immigration 9

2. New Life 19

3. Churches 43

4. The Arts 61

5. Windsor 81

6. People 93

7. Organizations 107

8. The Future 119

Bibliography 128

ACKNOWLEDGMENTS

I am indebted to many people who responded to my request for information and photographs quickly and generously. The preservation of the rich history of the Italian immigrants to Detroit will be thanks to the enthusiasm and support of the entire community.

A special recognition and thanks are sent to the following: Anthony Battaglia, the Bommorito/Valenti family, the Bonaldi family, Douglas Brombal, Antoinette Bye, the Caboto Club, Paul Calcaterra, Paul Cicchini, Kitty Daggy, David DiChiera, Santa Fabio, Lisa Bica Grodsky, Michael Hauser, Susan Liddell, Caterina Lopez, Chuck Maniaci, Sam Miele, Marie-Clotilde Pfaff, David Poremba, the Burton Historical Collection at the Detroit Public Library, Rose Riopelle, the Rossi family, Rinaldo Rotellini, David Rubello, Mary Jo Zanoni Schaffer, Lisa Silvestri, Maria Stante, Frank D. Stella, Linda Tripi, Armando Viselli, and the *Windsor Star*. I am especially grateful for the interest, advice, and support from the Italian American Cultural Society, Vittorio Re, Sergio DeGiusti, Tom Featherstone, the Walter P. Reuther Library at Wayne State University, Roman Godzak, the Archdiocese of Detroit Archives, Madelyn Della Valle at the Windsor Community Museum, and Rose Fucinari Vettraino.

INTRODUCTION

Italians in America. On reflection, this concept is quite profound. America as we know it in the 21st century has very long, strong roots in Italy. Christopher Columbus, John Cabot, and Giovanni Verrazzano explored the Western Hemisphere and claimed vast territories for Spain, England, and France. The very name America comes from Amerigo Vespucci, the first European to realize that the Western Hemisphere was a new world. Over the centuries, the New World has been heavily indebted to Italian culture. The strong Italian influence on Western civilization in politics, art, music, religion, and science has been reflected in American democracy, patterned after the Roman republic in ancient Italy. From the elegant architecture of the federal buildings in Washington, D.C., to the ubiquitous pizza restaurants in every American city, Italian contributions are in evidence everywhere.

Over the centuries, there has been a steady migration of Italians to America. Though few, the first arrivals made significant contributions. Christian missionaries to the Native Americans in Canada, the Mississippi Valley, Florida, and the Southwest were often Italians serving with French and Spanish orders. Silk workers went to the American South, glassblowers and architects were lured to the growing cities, and explorers and soldiers served the various colonial powers.

Detroit was founded in 1701 by order of the French sun king, Louis XIV. He charged Antoine de la Mothe Cadillac to establish a trading post and fort at the present site of Hart Plaza in Detroit. Cadillac's second in command was Alphonse Tonty, the son of an Italian immigrant to France whose Italian name was Alfonso Tonti. The first European child born in Detroit was born to Tonti and his wife in 1703. When Cadillac was ordered back to France, Tonti became the commander of the fort.

Despite this illustrious beginning, the Italian presence in Detroit and Michigan grew slowly. The French, and then the British after them, discouraged immigration to Michigan to preserve the fur trade in the region. It was only after Michigan became American and the Erie Canal was built that real growth began in the area. While Detroit grew rapidly in the later 19th century, Italian immigration lagged behind other cities in the East. By the beginning of the 20th century, there were a few hundred Italians resident in the city, mostly Genoese, Lombards, and Sicilians, living east of what is now known as Greektown and in Eastern Market. Larger numbers passed through Detroit on their way to the mines in northern Michigan.

The growth of Detroit in the first half of the 20th century is directly related to the development of the automobile industry. The city grew from just over 200,000 inhabitants in 1900 to just short of 2 million in 1950. The Italian population also grew, from a few thousand in 1900 to 280,000 in 1990 (as estimated by the National Italian American Foundation).

Unlike many other American cities, no region of Italy was totally dominant in this area, though southerners were more numerous. Although there have been several neighborhoods that were heavily Italian, the immigrants and their children dispersed themselves into many parts of the city. The historical center of the community was along Gratiot, east of downtown. Unlike some other national groups, like the Poles, who still look to Hamtramck, or the Mexicans, who have Mexicantown, Italian Detroiters no longer have a geographical center, although on Garfield Road in Clinton Township, there is a remaining cluster of Italian restaurants and shops. For many Detroiters, a trip across the Detroit River to Windsor in Ontario, Canada, is the chance to experience a compact Little Italy, also known as Via Italia, along Erie Street.

The history of Italian immigrants in Detroit is heartwarming. Tens of thousands of young men and women came to Detroit from an impoverished Italy to provide a better life for their children. Many thousands chose to do so by earning money in Detroit to buy property in Italy, and they returned to their villages and farms. Many more stayed in America, returning to Italy to wed and bringing their wives and families to begin life in a new world. Women rarely immigrated alone. Adjusting to a strange land, urban life, and a different culture, was difficult, but the rewards made it worth while. Many worked in the new factories making automobiles; many others worked in construction or food distribution. Clustered in among their countrymen, the immigrants worked hard and saved to provide themselves with a better life than they had know in the Old World.

Immigrants streamed into Detroit until the 1920s. People migrated north on Gratiot from the Italian neighborhoods downtown into formerly German neighborhoods, and then further north, sharing the new subdivisions with other immigrants. Some moved to areas south and west of Highland Park and southwest toward Dearborn and Downriver. By the 1950s, Italians could be found throughout the region.

While some of the first generation of immigrants became successful business and professional leaders, the labor and sacrifices made by the immigrants especially bore fruit in the subsequent generations. Hard work, sacrifice, devotion to family, and pride resulted in today's Italian Americans, some of whom are national leaders in business, art, music, the trades, and other professions. From factory workers, skilled workers, and stay-at-home moms to politicians, policemen, firemen, teachers, barbers, and restaurateurs, Italian Americans have made a tremendous contribution to this region, to America, and, indeed, to the world. Italian Americans and their friends and neighbors have every reason to be proud of their heritage and their history. Here, in a few pages, is a testimony to this community.

One

IMMIGRATION

America has always been a beacon to the peoples of the world. The wilderness found by Christopher Columbus, John Cabot, Giovanni Verrazano, and other explorers offered seemingly unlimited space and possibilities to people that lived in poverty or oppression in the rest of the world. To residents of the newly united Italy of the late 19th century and early 20th century, it held hope for a life without poverty or class distinction. Millions of Italians from all parts of Italy found their way to the New World. Large numbers went to America to earn money so that they could return to their villages and buy land or establish businesses in their hometowns. Many young immigrants eventually went home to a brighter economic and social future in their own hometowns.

Millions stayed in America, braving a new culture and language to forge a new life for themselves and their families. Although most of the immigrants from Italy were young men with little education, most were able, through hard work, tenacity, and a spirit of cooperation, to not only survive but also to thrive in the New World. Bolstered by love of family, the solace of religion, and a willingness to work hard for long hours, the immigrants managed to overcome the obstacles they encountered and shaped a new strong community. Their sacrifices resulted in improved economic situations and the forging of a new uniquely Italian and American culture.

During the first half of the 20th century, Detroit had particular allure because of its high-paying jobs and phenomenal growth. Thus, many immigrants settled here after first working in other parts of America. The boom years for Italian immigration to Detroit were from the beginning of the 20th century until the quota system cut off mass immigration in the 1920s. After World War II ended, another growth spurt occurred that lasted until the late 1960s. These later immigrants found many of the same conditions that existed for the preceding generation but had an established community in existence and the increasing prosperity of the postwar years to cushion the adjustments somewhat.

The "economic miracle" that followed World War II in Italy put an end to the need for emigration. The Italian community in Detroit, as well as in rest of the world, could no longer count on adding numbers from the homeland. Prosperity, assimilation, and increasingly easy communication and travel insured that Italian Detroit would evolve in its own way.

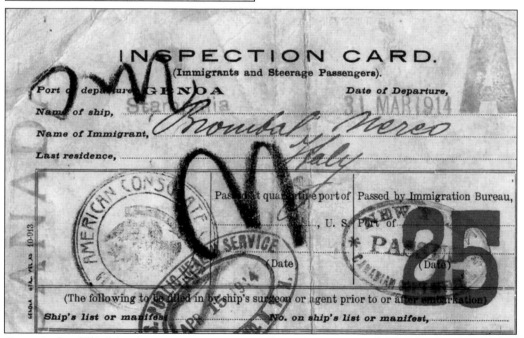

Nereo Brombal, at age 17, set out from his native Caesano S. Marco in Treviso for North America in March 1914. Like hundreds of thousands of other young Italian men, he was setting out to seek his fortune and to provide a more comfortable life for his future family. That war looming in Europe was another reason to leave. This document is his ticket on the ship *Spampalia*, which he boarded at Genoa on March 31, 1914, after it had taken on passengers at Palermo and Naples. La Veloce is the name of the steamship company. Two weeks later, on April 14, he landed at Ellis Island in New York. (Courtesy of Douglas Brombal, Windsor Community Museum.)

On arrival at Ellis Island, immigrants were issued an inspection card. This card indicates that Brombal passed the inspection for health and integrity and could debark at New York to proceed to his North American destination. In his case, the destination was Windsor, Ontario, across the river from Detroit. (Courtesy of Douglas Brombal, Windsor Community Museum.)

Immigrating to North America was not simple. To board the ship for North America, Nereo Brombal needed to answer a medical questionnaire in Italy, as well as submit to a medical exam in New York. This medical questionnaire indicates that the Italian doctor attests that he is healthy. It is signed by the doctor as well as by the mayor of his hometown. (Courtesy of Douglas Brombal, Windsor Community Museum.)

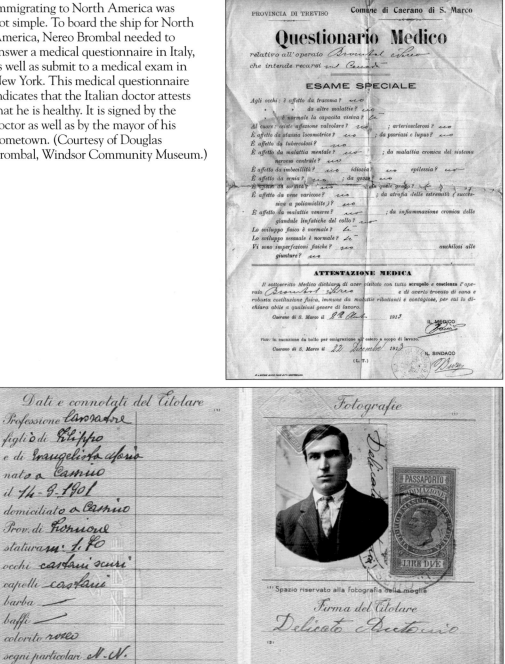

A familiar document in the early days of the 20th century was the passport issued by the Kingdom of Italy to many millions of its young people who were leaving to improve their chances in life abroad. This young man, Antonio Delicato, set out to America to seek his fortune and expected to return to his hometown of Cassino in Lazio so that his family would be landowners instead of tenant farmers. Delicato, like many early immigrants, eventually changed his mind about farming. He chose to remain in Detroit and brought his family to America. His next passport would be issued by the United States of America.

CERTIFICATE OF CITIZENSHIP

Petition No. 123818

Personal description of holder as of date of naturalization: age 38 *years; sex* male *color* white *complexion* medium *color of eyes* brown *color of hair* black *height* 5 *feet* 6 *inches; weight* 155 *pounds; visible distinctive marks* none
Marital status Married *former nationality* Italian
I certify that the description above given is true, and that the photograph affixed hereto is a likeness of me.

(Complete and true signature of holder)

(SECURELY AND PERMANENTLY)

EASTERN DISTRICT OF MICHIGAN *ss.:*
SOUTHERN DIVISION
Be it known that Antonio Delicato
then residing at 3732 McDougall Ave., Detroit, Mich.
having petitioned to be admitted a citizen of the United States of America, and at a term of the District Court of The United States
held pursuant to law at Detroit *on* July 24, 1939 19
the court having found that the petitioner intends to reside permanently in the United States, had in all respects complied with the Naturalization Laws of the United States in such case applicable and was entitled to be so admitted, the court thereupon ordered that the petitioner be admitted as a citizen of the United States of America. In testimony whereof the seal of the court is hereunto affixed this 24th *day of* July *in the year of our Lord nineteen hundred and* thirty-nine *and of our Independence the one hundred and* sixty-fourth.

GEORGE M. READ
Clerk of the U. S. District Court.
By Richard Telephone *Deputy Clerk.*

Seal

For thousands of immigrants, this document was the Holy Grail. American citizenship meant permanent residence in the United States, and, after the Quota Act was passed in the 1920s, it presented the possibility of having priority in bringing loved ones to America. Antonio Delicato's wife and children were still in Italy, and it was time to reunite the family. With war once again threatening Europe, America seemed to be a safe haven. As a citizen of the United States, Delicato was able to begin the process that would bring his family to their new home in Detroit.

Form VP-1
V285702

U.S. DEPARTMENT OF LABOR
IMMIGRATION AND NATURALIZATION SERVICE
WASHINGTON, D. C.

10-26-39

Your "Petition for Issuance of Immigration Visa" has been approved and forwarded to the Department of State for transmittal to the appropriate consular officer.

If you petitioned for your husband, where the marriage occurred on or after July 1, 1932, or your parents, the granting of the preference status does not necessarily mean immediate issuance of the visa, but allows a certain priority on the waiting list for quota visas.

It is necessary that an applicant for a visa apply outside of the United States to an American Consul for such visa.

All inquiries regarding the issuance of immigration visas should be addressed to the nearest American Consul.

In many cases, immigrant men returned to Italy to marry in their hometowns. By the mid-1920s, the quota system drastically limited the number of Italians that could enter the United States. To reunite family members in America, a petition for an immigration visa had to be submitted. In this postcard, the Department of Labor indicates that Antonio Delicato has received approval to bring his wife and two daughters to the United States as immigrants. Because of quota restrictions, this approval was viewed as a godsend.

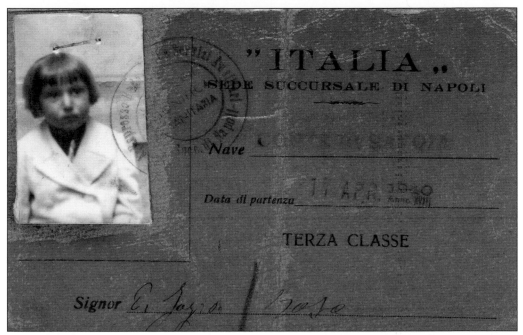

This card was issued on board the *Conte di Savoia* to Rosa DiFazio, whose real name was Rosa Delicato, indicating that she had been disinfected, vaccinated, and bathed before she was allowed to disembark from the ship in New York. She was able to enter the United States and begin her new life. (Courtesy of Rose Riopelle.)

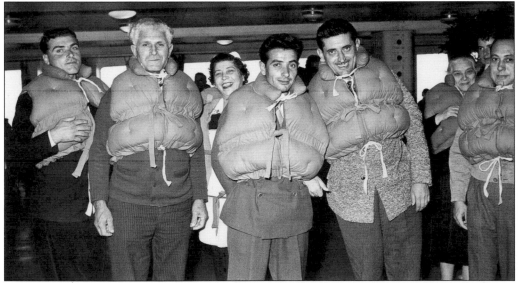

As times changed, so did the mode of transportation between Italy and the United States. In 1954, Michele Rossi, second from the left, and his companions participate in a safety drill on board the *Vulcania* while sailing to Italy to visit family that had not yet emigrated. By the 1950s, ships could make the trip from New York to Italy in five or six days, compared to the two- or three-weeks journey earlier in the century. Within a decade, the jet airplane would revolutionize travel, and visiting Europe would become much more convenient and affordable. (Courtesy of the Rossi family.)

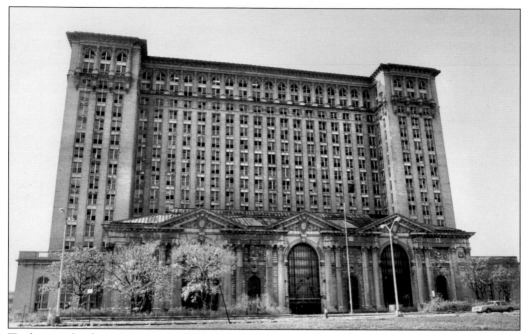

To thousands of immigrants, this building was the portal through which they were introduced to their new hometown. Until the 1960s, the train was the most common means of transportation from the East Coast to Detroit. With the advent of jet travel and superhighways, trains became outdated. This view of the Michigan Central Station illustrates the real and symbolic decline of rail travel in North America.

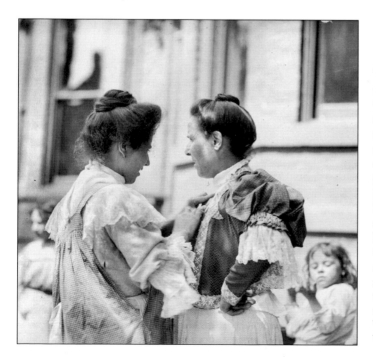

While single women rarely traveled alone, thousands of wives and sweethearts arrived to reunite with husbands or to marry immigrants who had arranged their passage. These women are newly arrived and setting up house in a strange land in the 1920s. These lucky women had relatives and friends from their hometowns to assist in the transition. Simple tasks such as shopping, finding medical assistance, and housekeeping were different and took effort to complete. (Courtesy of the Walter P. Reuther Library, Wayne State University.)

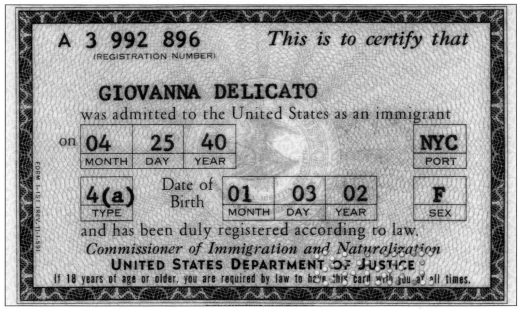

A 3 992 896
(REGISTRATION NUMBER)

This is to certify that

GIOVANNA DELICATO

was admitted to the United States as an immigrant

on | 04 | 25 | 40 | NYC
| MONTH | DAY | YEAR | PORT

4(a) | Date of Birth | 01 | 03 | 02 | F
TYPE | | MONTH | DAY | YEAR | SEX

and has been duly registered according to law.

Commissioner of Immigration and Naturalization

UNITED STATES DEPARTMENT OF JUSTICE

If 18 years of age or older, you are required by law to have this card with you at all times.

FORM I-151 (REV.11-1-59)

The famous green card was awarded to Giovanna Delicato after her arrival, indicating that she was a legal permanent resident of the United States. Although it never conferred citizenship, it was insurance that the holder was not in the United States illegally and could work, if necessary. Delicato was a resident of the United States for 52 years. An American and an Italian, she never formalized her American citizenship.

Alien Registration No. *3103683*

Name *Adela Bruno*
(First name) (Middle name) (Last name)

RIGHT INDEX FINGERPRINT

(Signature of holder)

Birth date *Dec. 22 1889*
Month (Day) (Year)

Born in or near *Genova Alessandria Italy*
(City) (Province) (Country)

Citizen or subject of *Italy*
(Country)

Length of residence in United States *21* yrs., *11* mos.

Address of residence *9824 Dequindre*
(Street address or rural route)
Hamtramck Wayne Mich.
(City) (County) (State)

Height *5* ft., *2* in.

Weight *140* lb

Color of hair *black*

Distinctive marks *none*

DETROIT, MICH.
FEB 23 1942
M.O.B.

Rita J. Mulawa
(Signature of Identification Official)

Application filed in Alien Registration Division. Copy filed with Federal Bureau of Investigation office at

Immigrants who chose not to become citizens of the United States were required by law to procure an alien registration card and to report to the Alien Registration Division each year until the requirement was ended in the 1960s. During World War II, Italians were technically enemy aliens and subject to suspicion by the government and many fellow Americans. Notice that the card includes a fingerprint and photograph. Very few Italians were found guilty of aiding the enemy during the war. Almost all Italians in America were loyal to their adopted country. (Courtesy of the Italian American Cultural Society.)

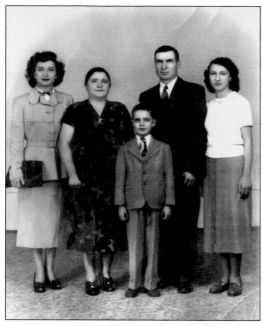

A post–World War II family portrait was an important way to let relatives and friends in Italy know how the family was growing at a time when travel across the Atlantic was costly and slow. It was rare for Italian Americans to travel to Italy and even more rare for Italians to visit America. The Delicato family, seen here from left to right, Antoinette, Giovanna, Armando, Antonio and Rose, presented a prosperous and happy look to the extended family back in Cassino in 1948.

Mr Delicato Antonio

14556 Prevost.

Detroit Mich. 48227-

U. S. A.

PER VIA AEREA - PAR AVION
BY AIR MAIL - MIT LUFT POST

Adjusting to their new life in America, immigrants and their families continued to sorely miss their family and friends in Italy. A familiar sight in their homes was the red, light grey, and green colors of the Italian airmail envelope. The mailman was a welcome sight when he delivered a letter with greetings and news from home. When the envelope included a photograph, it was even more exciting. This was the tie that kept family and friends up-to-date with news of daily life. Later generations have been able to use jet airplanes, telephones, and the Internet to maintain family ties.

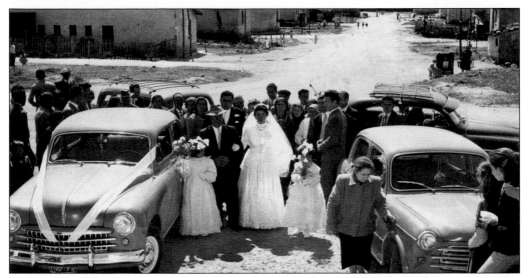

By the 1950s, life in Italy slowly began to return to normal and rebuilding had progressed. This couple, Lisetta Ruscillo on the arm of her father, Antonio, and her new husband Giovanni Mastronardi, are embarking on a new, hopeful life together. Lisetta's father had lived in Detroit during the 1920s and earned enough to buy farmland in his hometown of Cassino. His family's prosperity was short lived, however, when the Battle of Monte Cassino resulted in the complete destruction of everything the family owned. A return to Detroit was contemplated, but the quota system intervened. With some help from American relatives, hard work, and the Italian economic miracle, they managed to lead a happy, prosperous life in Cassino.

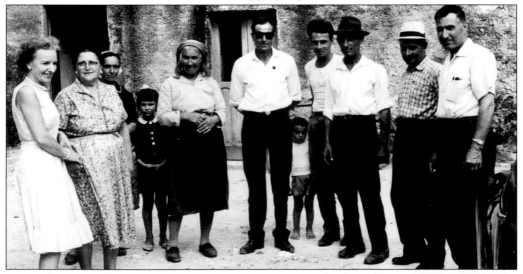

A visit home can be a bittersweet event for immigrants who have been away for many years. Antonia Evangelista, fifth from left, welcomes her brother Antonio, far right, and his wife, Giovanna, second from the left, back for a visit in 1962. They had not seen each other since he had last visited in 1937, and Giovanna had emigrated to America in 1940. Even while experiencing the joy of reunion, though, it was obvious that times had changed. The Italian Americans realized that they were no longer fully Italian, even as they were not fully American. Fortunately, with the advent of the jet age, travel had become more convenient and affordable. Family ties, so important to Italians wherever they live, could be maintained more easily.

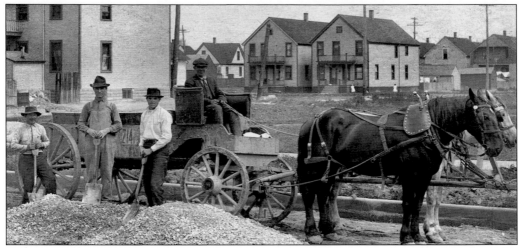

Construction work was a typical occupation for many farmworkers from southern Italy in the early 20th century. Detroit grew very rapidly after the advent of the automobile industry was established there. While many new arrivals eventually went to work in the factories, a large number found construction more to their liking because it involved being outside in a less-regimented situation than the factory. This picture, taken in 1915, shows a young Michele Rossi in the white shirt, working on a street-paving project. Notice that the backbreaking work of the time did not include the assistance of machines. The horse waited while the men worked. (Courtesy of the Rossi family.)

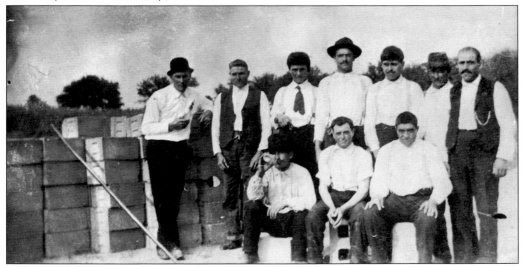

This grounds-keeping crew at Cranbrook Institutions in 1906 consisted of young men who emigrated from the town of Sant'Elia in the Ciociaria, south of Rome. They are, from left to right, as follows: (seated) Vincenzo Rancone, unidentified, and Gaetano Vettraino; (standing) Antonio Soave, Giuseppi Vettraino, ? Angelocanto, Michele Vettraino, Vincenzo Fragnoli, Felix Angelosanto, and Marco DiPonio. Outside work was more appealing than confinement in a factory for many farmworkers from Italy. Michele Vettraino was the head of landscaping for Cranbrook and was given the responsibility of meeting the exacting standards of Henry Booth, the founder and benefactor of the institution. Booth was happy to have Italian crews because they worked hard and well. The tradition of Italian workers began in 1906 and continued through most of the century. (Copyright Cranbrook Archives, FD122-1. From the Vettraino Family Papers.)

Two

NEW LIFE

While many Italian immigrants to Detroit were artisans or professionals, the majority were poor farmers with little education and few resources. Very few arrived in the New World comfortable with the English language. The northern European–based culture of Michigan offered barriers of language, religion, and custom. Into this usually indifferent, often hostile, environment, these immigrants were able to forge a new life. The new Detroiters initially huddled together in neighborhoods east of downtown and later near places of employment throughout the city and suburbs. These Italian workers and their families found that hard work and sober living could lead to the achievement of their dreams of prosperity in America and the survival of their folk culture from Italy. Change meant the absorption of some American values, while holding on to those they brought from their homeland. The family has always been paramount in all segments of Italian life. The psychological security that is fostered by strong family ties gives strength to young people as they strive to succeed in life. Religion has also played an important role in maintaining the culture, even as Italians blended into American Catholicism or other Protestant churches. While the predominantly ethnic churches and parishes found in some other ethnic communities, such as among the Polish and German Catholics, were not paramount, Italian immigrants found their religious strength through their strong family life.

Socializing for the first generations usually consisted of family- and friend-centered entertaining and the celebration of life's rituals: birth, coming-of-age, courtship and marriage, and death. Usually these events had a religious component as well as being an outlet for fun. Naturally, being Italian, they always included abundant, delicious food and wine. Even into the 21st century, family dinners, visiting friends and relatives, and celebrating together have remained the basis for sociability in Italian culture. As prosperity has increased, Italians have included a taste for culture and the arts. Support for classical music and the arts is strong among the community today. Attendance at movies, theater, and classical and popular music concerts has become the norm for Italian Americans.

Each succeeding generation has seen its sons and daughters achieve educational and professional goals that seemed remote to the majority in the early days of mass migration. The sacrifices made by the immigrants for the betterment of future generations have proven fruitful. The lifestyles of Italian Americans more closely parallel those of the dominant American culture without eliminating the best of Italian folk culture. All Americans can be proud of the contributions made by the immigrants from Italy and their descendants. In most cases, assimilation into the mainstream of American life has been accompanied by a respect for the Italian culture passed on by past generations.

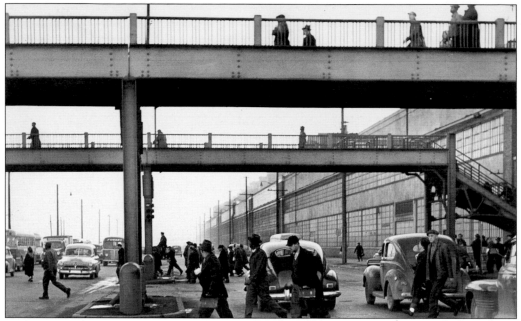

The rapid growth of industry in Detroit, especially automobile manufacturing, was the magnet that attracted hundreds of thousands of people, native and immigrant alike, to the city. These workers are seen leaving after their shift. The work was difficult, but the high-paying jobs in industry boosted many immigrants into the large middle class. Their children often entered the skilled trades, business, and the professions in fulfillment of their parents' dreams in coming to America. (Courtesy of the Italian American Cultural Society; Sam Saporito, photographer.)

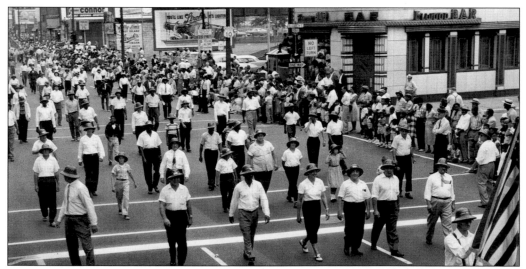

With so many Italian Americans in industrial or construction jobs, it followed that they became active in labor unions. This Labor Day parade down Woodward Avenue in 1957 shows the rank and file marching to celebrate their union solidarity. As time has gone by, many of their children have come to own their businesses as employers, yet many Italians are still active in labor unions today. (Courtesy of the Italian American Cultural Society.)

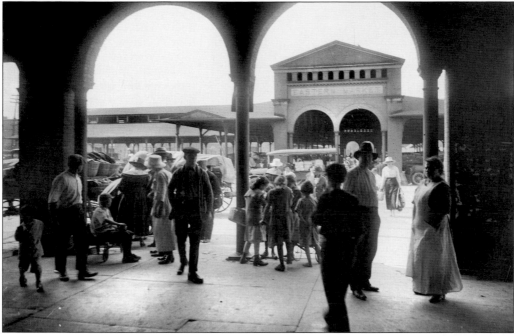

For over one hundred years, the Eastern Market has provided Detroiters with fresh fruits and vegetables from local farmers and from around the world. In addition, meat stores, spice shops, restaurants, and bakeries surround the food sheds in the market itself. The first Italian neighborhoods in Detroit surrounded the market, which was a steady source of the fresh foods that characterize Italian cuisine. These two pictures from the early years of the 20th century show how little the market has changed despite the changing fashions of the people. For decades, Italian was often heard among the crowds on Saturday mornings, as housewives replenished their pantries. Today the market serves a very mixed crowd of Detroiters that still includes many Italians. (Courtesy of the Walter P. Reuther Library, Wayne State University.)

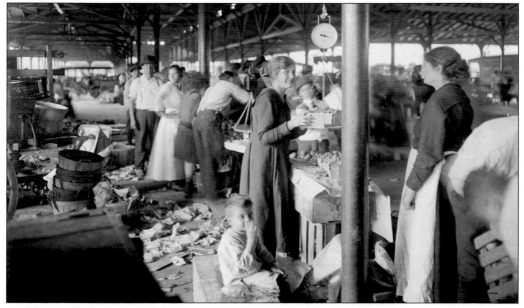

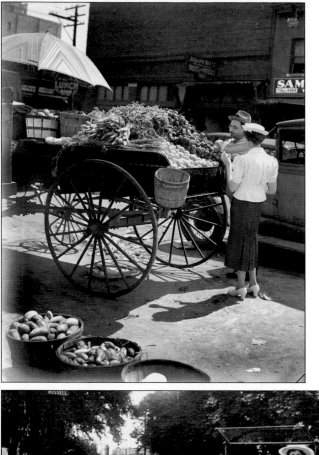

This woman purchases vegetables from a vendor's cart. In the past, many Italians would drive their horse-driven carts or small trucks through the neighborhoods of the city, selling fresh produce. The identification of Italians with the grocery business has survived with the growth of large-scale greengrocers such Nino Salvaggio's in Clinton Township. The Italian love of well-prepared, fresh food and a strong entrepreneurial spirit has resulted in a large number of Italian-owned restaurants and food markets. (Courtesy of the Walter P. Reuther Library, Wayne State University.)

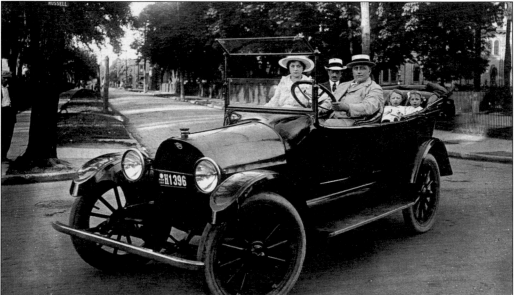

Taking a Sunday ride through the neighborhood on Russell Street in his new car is Alberto Grilli, owner of Grilli Soda Pop Company, with Gertrude Bonaldi sitting next to him. Her husband, Louis, sits in the back with two of their children, Angelo and Ada Bonaldi. Taken in the 1920s, notice the absence of traffic and the tree-lined street. Russell Street was later widened and became a busy commercial street north of the Eastern Market. Today it is the site of a large bottling plant. (Courtesy of the Bonaldi family.)

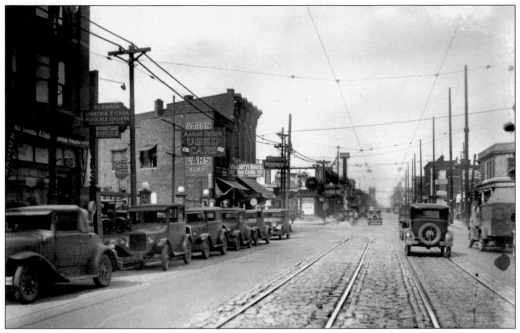

From the early to mid-20th century, Gratiot and McDougal was the center of the Italian community. This street scene is just north of the block containing Roma Hall, Bonaldi's, and Giglio's Market. At the time, it was a thriving center of commerce for the community. A CVS drugstore occupies the block today with no indication of the community that flourished at that intersection many years ago.(Courtesy of the Walter P. Reuther Library, Wayne State University.)

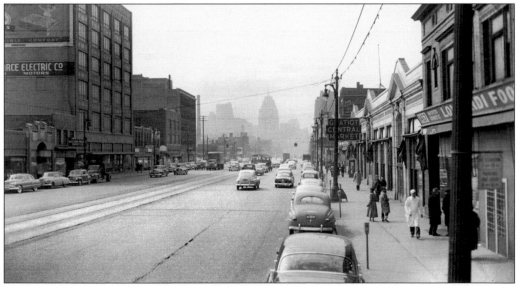

The intersection of Gratiot and Vernor Highway in the 1950s was already showing signs of decline. Many Italians had already moved up Gratiot or to other parts of the city, and the remainder would soon follow. This intersection at the entrance to Eastern Market, home once to retail outlets selling Italian products such as Lombardi Foods seen on the right, was demolished soon after this photograph was taken to make way for the Chrysler Freeway. (Courtesy of the Walter P. Reuther Library, Wayne State University.)

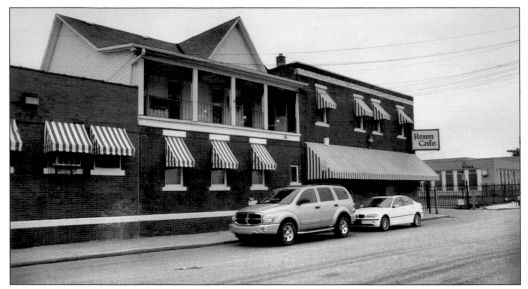

One of the few remaining landmarks from the days when Eastern Market was the center of a large Italian settlement is the Roma Cafe on Riopelle Street at the north end of the market district. The building was bought by the Marazza family in 1888 to serve as a boardinghouse for farmers coming to sell their wares at the market. Several years later, the Sossi family bought the building and quit renting rooms to concentrate on food. Much of the building's charm is its lack of pretension. The restaurant is still operated by Hector Sossi and his daughter Janet Sossi Belcoure, and it remains one of Detroit's favorite eating establishments.

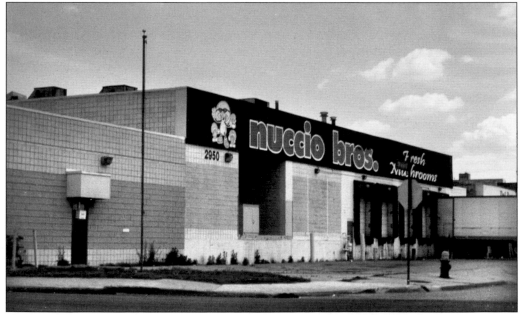

While traveling through Eastern Market today, one sees how many of the descendents of the grocers in early Detroit have managed to survive and prosper in the food business. Many food wholesalers and retailers in the Detroit area today are of Italian descent, as evidenced by the names on delivery trucks and wholesale distributors throughout the Detroit area. Pictured here is the Nuccio Brothers distribution center in Eastern Market.

On the streets surrounding McDougal and Gratiot Avenues in the old Italian neighborhood, few reminders indicate that this was once a thriving community of immigrants. The occasional overgrown grape vine and fenced in front yard are hints of the days when the majority of residents in this area were Italians. Sadly most of the community has been abandoned, and vacant lots predominate where the streets once pulsated with life.

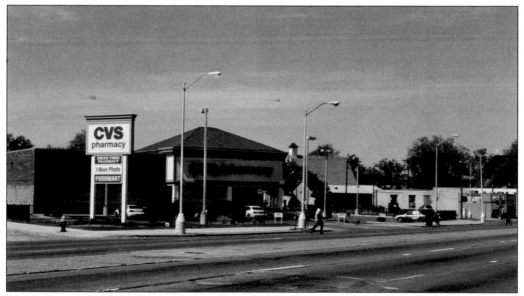

The intersection of Gratiot Avenue and McDougal Street was once the hub of a growing community of Italian immigrants. People once shopped at Giglio's Market and Bonaldi's Music and Book Store, or attended wedding receptions at Roma Hall on the corner of Gratiot Avenue and Mitchell Street. Residents could shop for all their needs at the various stores lining Gratiot and even the side streets. After many years of decay, the current residents have this modern drugstore serving their needs.

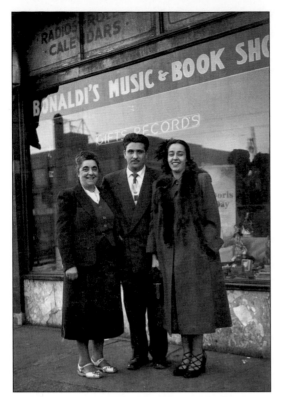

The Bonaldi family has operated stores selling Italian gifts, music, and other imported items since Angelo Bonaldi opened his first store in 1916 on Rivard Street. When he returned to his native Tuscany, the store was taken over by his son Louis, and he and his descendants have run the business since. Pictured here, from left to right, are Louis's wife, Gertrude Bonaldi, their son-in-law, Elio Benvenuti, and their daughter, Vida Bonaldi Benvenuti. At the time this picture was taken in 1951, the entire block between Mitchell Street and McDougal Avenue on Gratiot Avenue was occupied with Italian-owned businesses. Roma Hall was to the south of Bonaldi's store and Giglio's Market was to the north. (Courtesy of the Bonaldi family.)

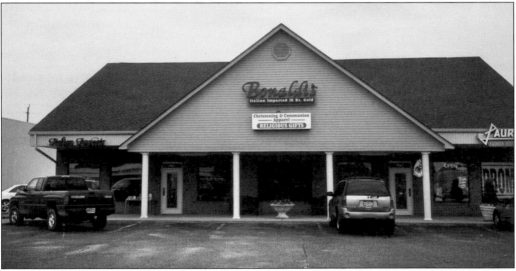

As the Italian community spread out, the Bonaldi's store followed. In 1965, the store relocated to Kelly Road in East Detroit, and in 1988, the store moved to Garfield Road in the heart of the new "Little Italy" in Clinton Township. Eddie Bonaldi took over the store from his father, Ezio, and runs it with the help of his mother, Mary, and sisters Rosanne and Donna. That makes four generations of the Bonaldi family to run the store. The latest location differs from the original in many ways, especially because there is a large parking lot attached. People come from throughout the metro Detroit region to purchase special gifts, cards, and music. (Courtesy of the Bonaldi family.)

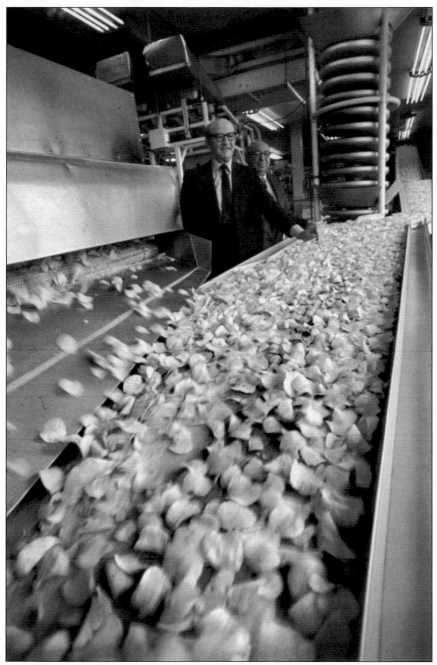

A familiar sight to east-siders for many decades has been the Better Made Potato Chip Company on Gratiot Avenue. The large windows have shown travelers a tempting array of potato chips being prepared and packaged. Not so obvious is that the company was founded in 1930 by Italian Americans Peter Cipriano, left in the picture, and Cross Moceri, to his right. That the locally owned and operated company has continued to exist in the same location is a tribute to the business acumen of the owners and the quality of their products. While potato chips are not a typical Italian snack food, the success of the company reflects Italian preference for quality in their cuisine. (Courtesy of the Walter P. Reuther Library, Wayne State University.)

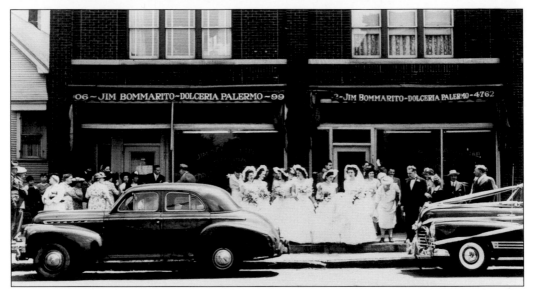

Jim Bommarito opened a bakery in Detroit in 1934 on Joseph Campau Street. Soon after, the bakery was relocated to Cadillac Street and Forest Street, where this picture was taken in 1946. Many small businesses dotted the neighborhoods of Detroit, serving people who would usually walk only a few blocks to shop for their daily necessities. Bommarito's daughter, Grace, sets out to Holy Family Church to be married to Sam Valenti, who was in the produce business. The young couple ran the bakery for many years at this location until 1961 when they moved to St. Clair Shores. (Courtesy of Christine Corrado.)

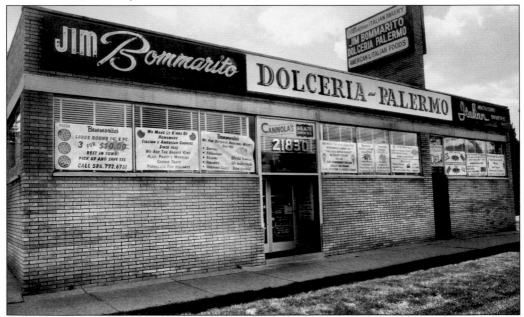

Like many of the businesses begun in the old neighborhood in Detroit before the 1950s, Bommarito's Bakery followed the population as many people moved into the Macomb County suburbs. Today the bakery stills sells breads, pastries, and imported food and wine in a warm atmosphere enhanced by the pictures of the "old days" that hang on the walls. (Courtesy of the Valenti family.)

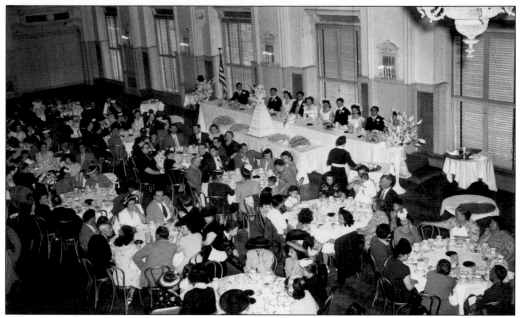

In the 1940s, many people in the Italian community did not participate in formal entertainment. Sunday afternoon visits to friends and family were the most common leisure time activity. Special occasions were therefore particularly special. This wedding reception for Grace Bommarito and Sam Valenti at the Book Cadillac Hotel downtown is a very happy celebration, deserving of a beautiful setting. (Courtesy of the Christine Corrado.)

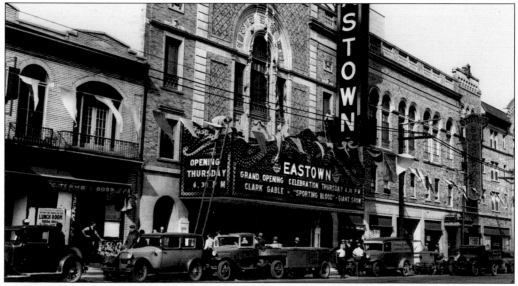

The Eastown, one of the largest neighborhood theaters in Detroit, was a source of entertainment for thousands of east-siders. Built in 1931 near the corner of Van Dyke and Harper Avenues, it served the large Polish community nearby as well as the large Italian neighborhood of Cacalupo to the east. Until the advent of television in the 1950s and the changing residential patterns of the 1950s and 1960s, this 2,500-seat theater was a popular second-run venue, where people gathered to see Hollywood's offerings. At places like the Eastown, American pop culture gained a foothold in immigrant families' lives. (Courtesy of Michael Hauser.)

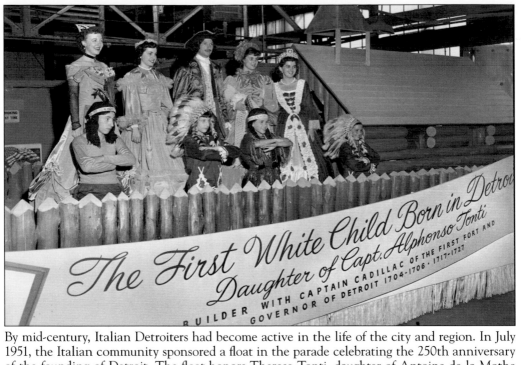

The First White Child Born in Detroit Daughter of Capt. Alphonso Tonti BUILDER WITH CAPTAIN CADILLAC OF THE FIRST FORT AND GOVERNOR OF DETROIT 1704-1706 · 1717-1727

By mid-century, Italian Detroiters had become active in the life of the city and region. In July 1951, the Italian community sponsored a float in the parade celebrating the 250th anniversary of the founding of Detroit. The float honors Therese Tonti, daughter of Antoine de la Mothe Cadillac's second in command, Alphonso Tonti, and the first European child born in Detroit. (Courtesy of the Walter P. Reuther Library, Wayne State University.)

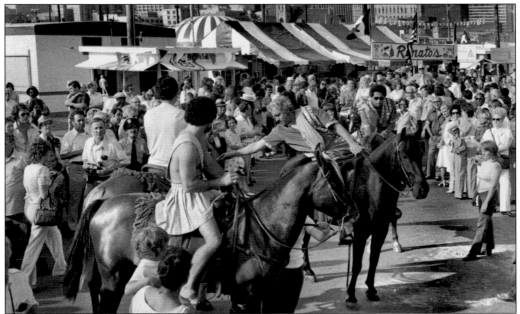

From the 1960s through the 1990s, Detroit celebrated its ethnic heritage by sponsoring riverside festivals downtown every summer. This photo shows Roman gladiators outside a booth selling sausage and pepper sandwiches. The festivals showcased Italian culture with performances and exhibitions in a fun-filled atmosphere. (Courtesy of the Walter P. Reuther Library, Wayne State University.)

From left to right, celebrating his daughter Jenny's confirmation, Michele Rossi relaxes on his porch with Joe Pittiglio, Antonio Tiseo, Dominic Vettraino, Oreste Rossi, Angelo Evangelista, and Antonio D'Alessandro. The men are friends from their hometown of Sant'Angelo in Italy, which they left years before for Detroit. (Courtesy of the Rossi family.)

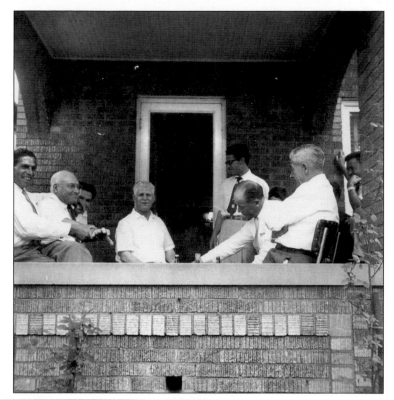

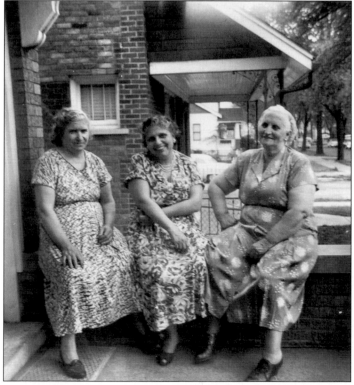

The men sat on the porch to pass away the summer afternoon, and their wives also relaxed on the porch after preparing dinner. From left to right, Rosina Rossi and her friends Gilda Evangelista and Maria Tiseo pause during the celebration of Rossi's daughter's confirmation celebration. The confirmation party included a feast with homemade wine and a multi-course dinner. Through the 1960s, these celebrations were often held at home. They now most often take place in restaurants and banquet halls. (Courtesy of the Rossi family.)

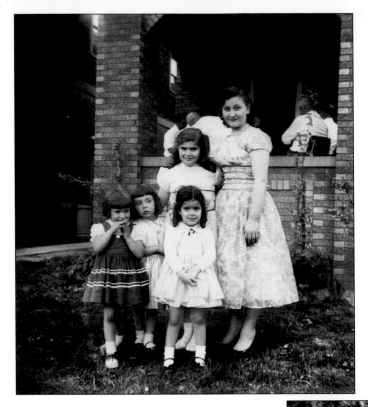

The little girls enjoy dressing up for the day-long celebration of Jenny Rossi's confirmation. From left to right, Rose Patillo, Lidia Vettraino, Angela Evangelista, Jenny Rossi, and Alice Serra pose in their party finery on the front lawn of the Rossi home on Petosky Street in Detroit. (Courtesy of the Rossi family.)

In the summertime, a relaxing picnic with friends at a park or in the country was a pleasant way to pass a Sunday afternoon. In this photograph, from left to right, Giulio Rossi, Gaetano Bosco, Sam D'Allesandro, an unidentified friend, and Michele Rossi pose for the camera at a family picnic. (Courtesy of the Rossi family.)

The wedding party of Maria Laudazio heads to Windsor in 1952 to visit family there. Since a Catholic wedding required a morning mass, weddings usually were all-day affairs that included lunch following the ceremony with a break followed by the evening supper and reception. Since many families had friends and relatives on both sides of the border, crossing to Canada was common.

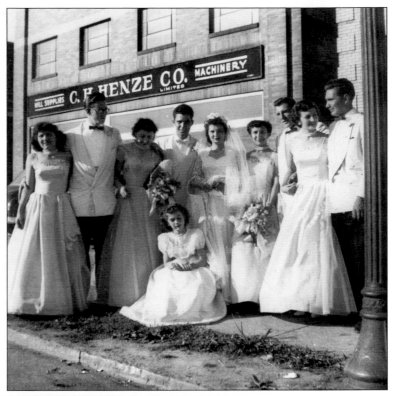

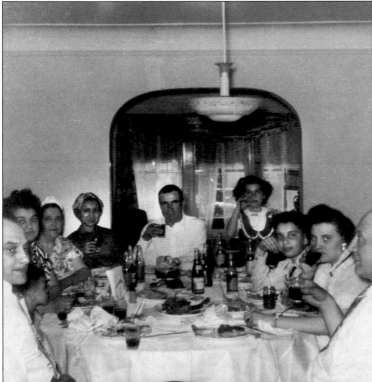

Confirmation is a milestone in the life of a Catholic Italian youngster. After the religious ritual, families celebrate with a banquet. In this picture, the family of Armando Delicato and the family of his *padrino* (godfather), Antonio Laudazio, celebrate this rite of passage. From left to right, Antonio Laudazio, his wife Maria, Laudazio, Giovanna, Antoinette, and Antonio Delicato, Diane Anthony, and Maria and Giovanni Laudazio are sitting at the dining room table.

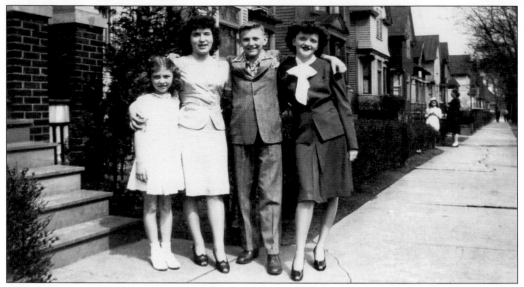

Standing in front of her house on Leland Street in the McDougal and Gratiot neighborhood in the early 1940s, Linda Miele (second from left) and her friends smile at the camera. In a neighborhood with many small lots close to one another, it was easy to make friends. Italians from all parts of Italy bonded, becoming friends and family. American-born children of immigrants often married people from other parts of Italy. (Courtesy of Linda Tripi.)

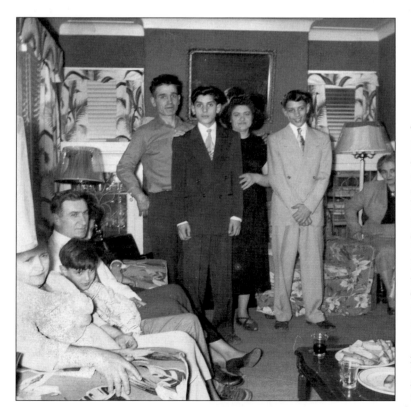

The social life of Detroiters of Italian descent revolves around the rituals of life relating to birth, coming-of-age, marriage, and death. Here Giacomo Buoncompani from Le Marche, Italy, and his wife, Catarina, from Calabria, celebrate the confirmation of their sons Peter and Paul. Peter's sponsor, Antonio Delicato, and his wife Giovanna and son Armando sit on the couch.

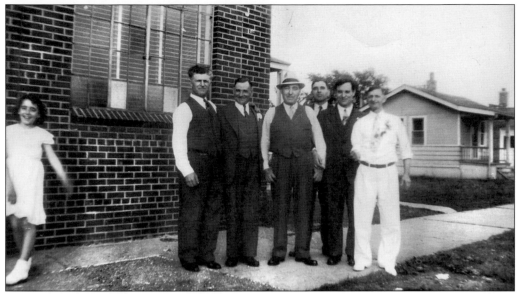

A wedding in the 1950s usually meant a day-long celebration held at a hall or restaurant. Note the formal attire of these men, Michele Rossi (left) and his friends, in the late-afternoon part of the reception. Informality meant removal of the jacket for most of the men, but not the tie. (Courtesy of the Rossi family.)

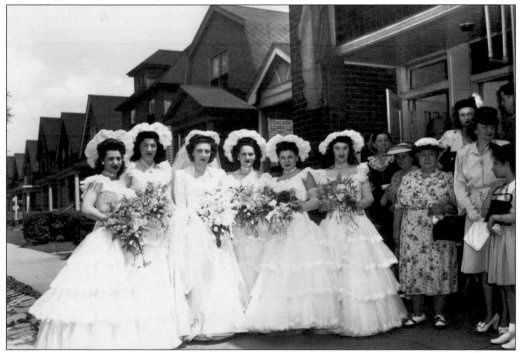

Rose Bommarito poses with her bridesmaids, mother, and other relatives on the sidewalk in front of the family's bakery on East Warren Avenue in 1946 before leaving for Holy Family Church, where she married Sam Valenti. A large wedding party was not uncommon, as young women often chose their sisters and cousins as well as close friends to be part of the wedding party. (Courtesy of Rose Valenti.)

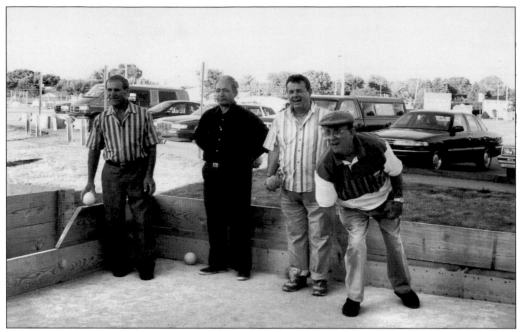

The game of bocce has been a favorite pastime for Italians for many generations. Because it does not require an elaborate court and can easily be played outside, men often get together in a field or on a lawn to enjoy a game with friends and pass time on a summer afternoon. In this game, Silvio Barile (third from left) and his friends are rolling the ball in a park. (Courtesy of Sergio De Giusti.)

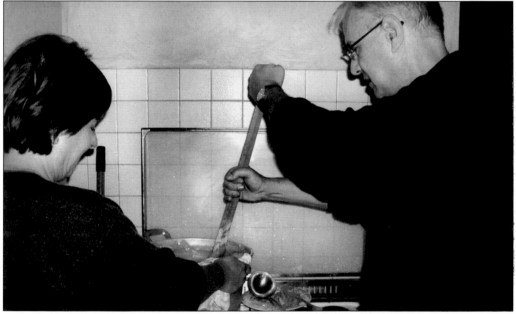

A tradition found especially in northern Italy, making polenta is often a family affair that leads to one of most Italians' favorite activities, fine dining. Preserving activities such as cooking polenta is one way that Italian traditions survive for succeeding generations. While it is a time-consuming process, it pays off by being delicious. Here Anunziatina Delicato and her cousin Armando Delicato stir the polenta so that it will be creamy and smooth.

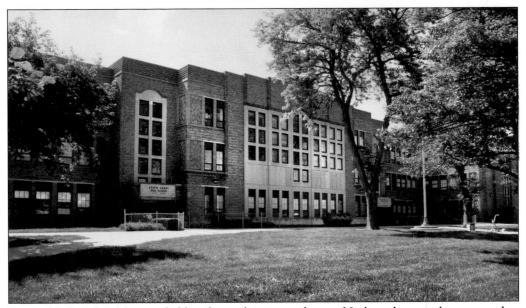

Denby High School has probably educated more students of Italian descent than any other in Michigan. Unlike other ethnic groups, such as the Poles, there has never been an Italian parochial high school, so no high school in the area could claim to be predominantly Italian. This school had almost 4,000 students attending during the 1940s through the 1960s, and many of them were of Italian descent. Many of the graduates have gone on to become business or professional leaders of the communities in which they live.

The large Italian community known as Cacalupo no longer exists at Gratiot Avenue and Harper. Though almost all have moved away, the former neighbors have attempted to remain in touch and celebrate the community they had. This program is from the 1978 reunion dinner dance in Roseville. The highlight of the evening was the famous musician and screen star Johnny Desmond, a native Detroiter whose real name was Giovanni de Simone. Wonderful memories have been shared at these reunions. (Courtesy of the Italian American Cultural Society.)

Cacalupo Reunion Dinner Dance

The Imperial House
34701 Groesbeck Hwy.

Friday, 7 p.m. February 10, 1978

PROGRAM

Short Introduction

by Our CHAIRMAN..................................RUSSELL GAMBINO

Invocation by.................................Fr. HECTOR SALENO

Dinner Served at 8 p.m.

Entertainment By Our Own JOHNNY DESMOND

Music..................JOHNNY CICALA

Chairman: Russell Gambino *Secretary:* Argie Gambino

COMMITTEE

Mike Ales	Frank Sansone	Al Bongiorno
Pat Ales	Lenora Sansone	Marg Bongiorno
Tony Bongiorno	Carl Comito	Tony Vitale
Mary Bongiorno	Rose Comito	Madelene Vitale
Al LaTorre	Al Marchionda	Victor Ventimiglia
Barbara LaTorre	Frances Marchionda	Virginia Ventimiglia

One of the most amazing stories of the Italian immigrant experience in World War II was that of Casimir Torrice. His family immigrated to Detroit in 1936 from Cassino in the Ciociara when he was 16 years old. A few years later, he was drafted into the United States Army and sent to the Cassino front in Italy. After digging their foxholes, Sergeant Torrice became ill with disbelief when he realized that he was on his family farm. He was given permission to seek out his family, but the whole village had escaped into the mountains. He and a companion stumbled onto a group of refugees that included his parish priest hiding in the forest. When they heard him speak the local dialect, they were astounded and overjoyed. He returned with some provisions for the refugees. Torrice spent four months fighting the Battle of Monte Cassino, during which he was wounded and sent to Rome to recuperate. He eventually married his Red Cross nurse, Anna Ridolfi, and returned to America. (Courtesy of Genoveffa Torrice Capaldi.)

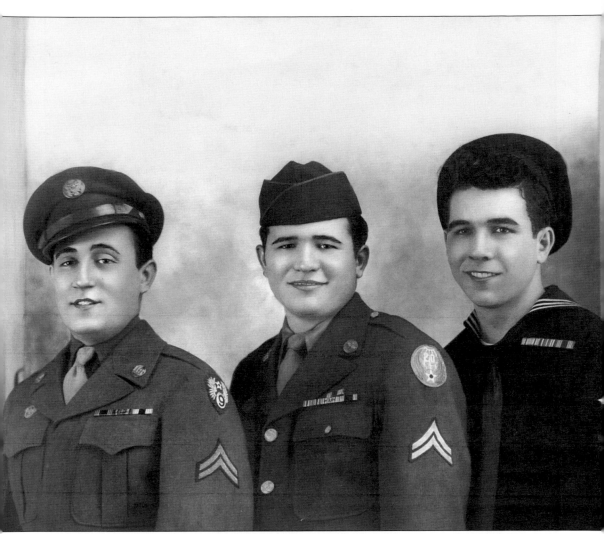

The 1940s were a difficult time for Italian immigrants and their families. The homeland, to which they still held strong emotional and familial ties, had become an enemy to their new country. Complicating the situation was the distrust and hostility that many American neighbors felt toward them. Nonetheless, Italian Americans were almost unanimous in their support for their new land. Mariagiovanna and Angeloantonio Miele had the added burden of sending three sons to fight for their country. There were three stars in the front window of their home on Leland Street, and it was with tremendous relief that Tony, Armando, and Sam, pictured here from left to right, returned safely. (Courtesy of Sam Miele.)

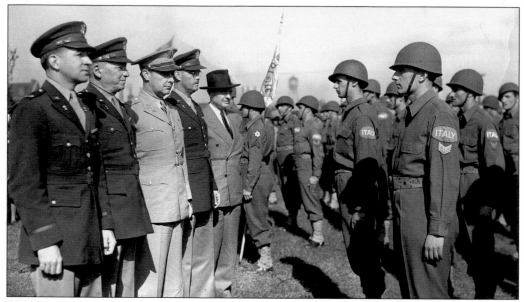

World War II was a very difficult time for Italian Americans. Not only was the homeland experiencing a brutal war that threatened the lives and well-being of loved ones, but young men, family, and friends were fighting on all fronts of the war. Compounding the agony was the fact that Italy and the United States were enemies during the first few years of the war. Shown here are Italian prisoners of war who were interned at Fort Wayne and at the Michigan State Fair Grounds in Detroit. (Courtesy of the Walter P. Reuther Library, Wayne State University.)

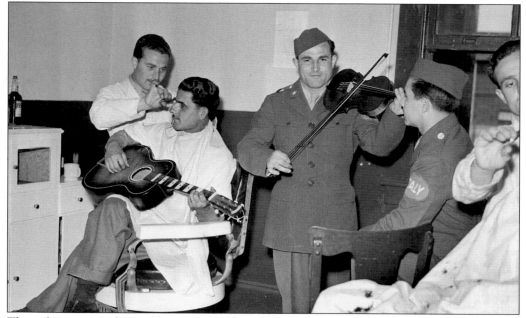

These fortunate Italian soldiers were held prisoner at Fort Wayne, where they were safe from the dangers of war. They were able not only to sit out the war in relative comfort but also to participate in occasions of social contacts and even dances with members of the Detroit community. A number of these men became "war husbands" and returned to live in the area after the war ended. (Courtesy of the Walter P. Reuther Library, Wayne State University.)

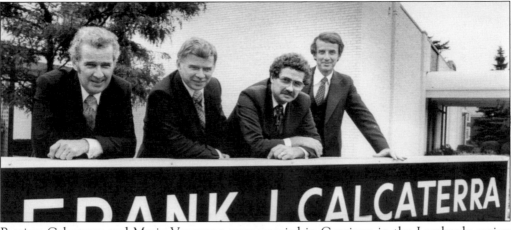

Battista Calcaterra and Maria Venegone were married in Cuggiono in the Lombardo region of Italy in the late 1800s, shortly before leaving for America. In Detroit, their son Frank cared for the horses of Mr. Hess, a German undertaker in the Eastern Market neighborhood. He was encouraged to learn the undertaking business because the Italian community was growing and Mr. Hess could not handle the increase. Calcaterra Funeral Home was founded across the street from San Francesco Church at Brewster and Rivard Streets. Frank's brother Louis joined the business and, eventually, his four sons did as well. As the community grew and people settled farther away, the funeral home followed. In 1937, it relocated to East Grand Boulevard and, in 1950, opened another chapel on Seven Mile and Kelly Roads. Pictured here are Louis's four sons. From left to right, the Calcaterra brothers are Frank F., Louis C., Paul R., and Lawrence M. (Courtesy of Paul Calcaterra.)

Frank Bagnasco opened his funeral home in 1915 at St. Aubin Street and Canfield Avenue near the Eastern Market. The Bagnasco family of Sicily served Italian families on the east side of Detroit for many years. When Frank Bagnasco died in 1937, his widow, Bessie, took over the business with assistance from her sons Sam and Tony. They moved the chapel to East Grand Boulevard and served the expanding community from that site until 1964, when they opened a new location in St. Clair Shores. The Bagnasco and Calcaterra families both ran funeral homes that served both the Italian community and their neighbors, and they merged in 2000. In the photograph of the officers taken after the merger, the oil painting on the left is of Frank J. Calcaterra, while that on the right is of Frank Bagnasco. The officers are, from left to right, as follows: (first row) Jackie Moody, Victor Kosticoff, and Brian Moler; (second row) Robert Wilk, Robert Schmidt, Robert Galvin, Jonnie Calcaterra, Frank Calcaterra, and Bill Bagnasco next to his grandfather's portrait. (Courtesy of Paul Calcaterra.)

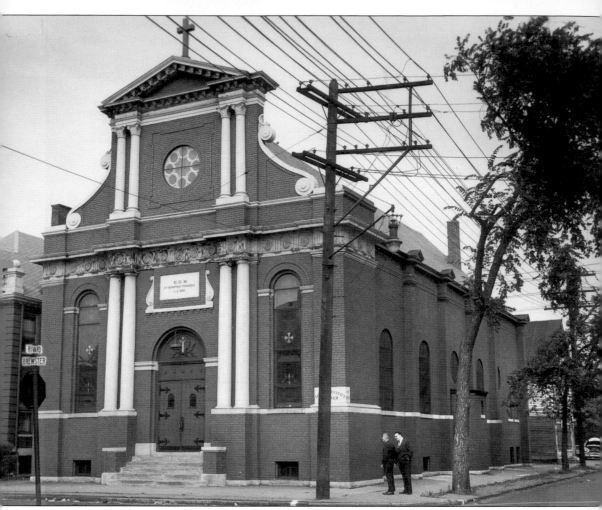

The first ethnic Italian parish in Detroit was San Francesco, located in Eastern Market where the Chrysler Freeway now crosses Brewster Street. Fr. Francesco Beccherini came to Detroit in 1897 and took a census that showed an Italian population of almost 2,000. This church, built in 1898, served the community for many years. The baroque exterior is reminiscent of many churches found throughout Italy. Father Beccherini served the people of San Francesco for 47 years, as the parish grew. As the Eastern Market expanded and the Italians moved to other parts of the city, San Francesco continued to draw people to their home parish. Even when the church property was sold, the parish continued to serve the Italian community from the Patronage of St. Joseph parish facility. (Courtesy of the Archdiocese of Detroit Archives.)

Three

CHURCHES

Much of Italian culture centers on religious life. From baptism to confirmation, marriage, and death, the church plays an important role, and where faith is not so important, celebration of life's cycles remains.

Fr. Francesco Beccherini came to Detroit in 1897 and convinced the bishop to allow him to form an Italian ethnic parish, San Francesco. The church, built at the corner of Rivard and Brewster Streets, served the Italians north of Gratiot, predominantly of northern Italian stock. South of Gratiot, most of the Italians were from Sicily. Though they attended the local American parish, Sts. Peter and Paul, they wanted a church of their own. Fr. Giovanni Maria Boschi, a Jesuit, arrived in Detroit in 1907 and formed Santa Famiglia Parish, Holy Family, which still stands at Lafayette Street and the Chrysler Freeway service drive and is the home church for many Sicilian Detroiters. As the community grew, so did the demand for parishes. Santa Maria was formed south of Highland Park, where the Chrysler Freeway is now located; the Church of the Madonna is west of Highland Park on Oakman Boulevard; and Our Lady of Mount Carmel was formed in southwest Detroit on Oakwood Boulevard.

Of these parishes, only San Francesco and Santa Maria opened schools. San Francesco was staffed by the School Sisters of Notre Dame from Milwaukee, a predominantly German order, while Santa Maria attracted an Italian teaching order, the Sisters of St. Dorothy.

Most Italian Americans lived in mixed neighborhoods and attended the local parishes. Following Gratiot Avenue north and Warren Avenue east, Italians settled into St. Elizabeth, St. Anthony, Nativity, Patronage of St. Joseph, St. David, St. Margaret Mary, St. John Berchman, St. Jude, Assumption Grotto, and many others parishes, extending into Macomb County. The same occurred on the west side of Detroit and in Dearborn and Downriver.

When San Francesco Church was condemned to make way for the Chrysler Freeway, parishioners petitioned to keep the church open, and in 1986, a new church was built near Gratiot Avenue and Metropolitan Parkway to serve the Italian community in Macomb County. Although it incorporates a few religious items from the old church, San Francesco is now a modern church. The Holy Family Church in downtown Detroit is the only other Italian Catholic church left in the region.

While Detroit Italians were predominantly Catholic, many joined other churches. By 1914, the First Italian Presbyterian Church had been formed and survives today as the Faith Presbyterian Church in St. Clair Shores. There were also Italian churches with Baptist, Methodist, and other denominational affiliations. None of these churches survive as ethnic churches.

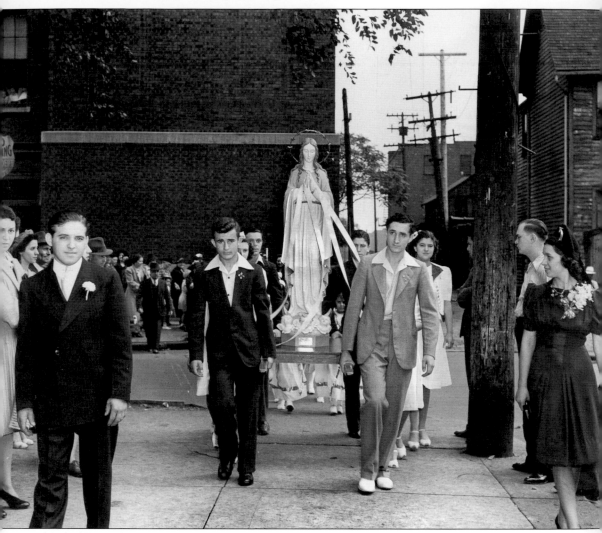

In Italian villages and city neighborhoods, the patron saints are honored with processions through the community and a festa in the evening. Since Detroit Italians originated in many regions of Italy and from thousands of villages, only the major feast days have been celebrated here. This 1940s procession honors the Assumption of the Blessed Virgin Mary, a national holiday in Italy, in August. (Courtesy of the Archdiocese of Detroit Archives.)

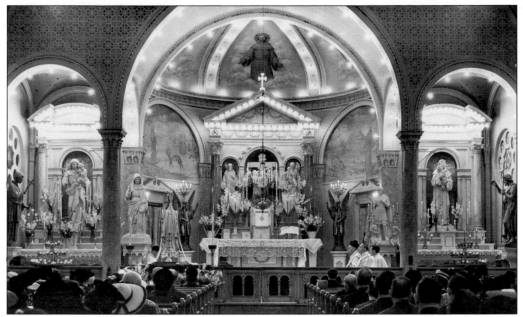

The interior of San Francesco parish's original church was very ornate, with statues of many favorite Italian saints. A school was organized and a new building was built in 1923 with the School Sisters of Notre Dame supplying the teachers. The school closed in 1953, as the neighborhood became more commercial and Italians moved to other parts of the city. (Courtesy of the Archdiocese of Detroit Archives.)

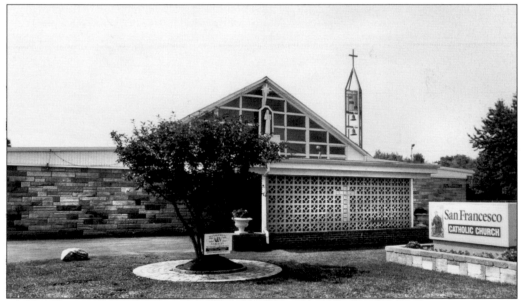

In 1986, this new church dedicated to San Francesco was open for worship. The old church had been demolished as part of an urban renewal, and, after three years of sharing facilities at the Patronage site, the parish moved to Oakland Avenue until it was able to follow its members to Clinton Township. Recently renovated, the new church will serve metro area Italians for many years to come. Although some architectural artifacts were transferred to the new edifice, a very contemporary design in the new building reflected the changing times.

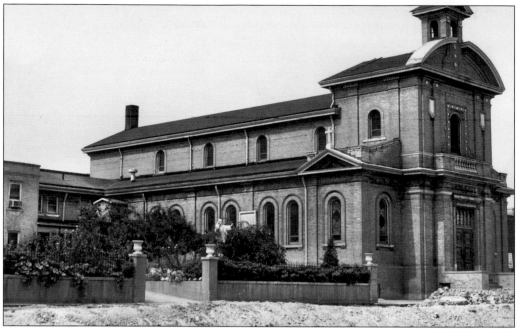

As immigration increased after the turn of the 20th century, it became evident that another parish would be necessary to serve the people living south of Gratiot Avenue. Now sitting on the edge of the Chrysler Freeway in the shadow of the Blue Cross Building, Santa Famiglia is the only Italian church still situated in the old neighborhood. Many Italians from metro Detroit, especially Sicilians, still belong to the parish or come for significant rites. Both the exterior and interior of the church are beautiful examples of baroque architecture. (Courtesy of the Archdiocese of Detroit Archives.)

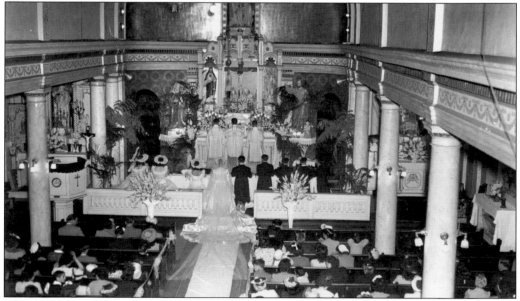

Although the parishioners moved away from this neighborhood on the edge of Greektown, the church is still popular for suburbanites attending Sunday mass and for weddings and funerals. It remains one of the few Italian institutions still located in the heart of the city, where Detroit's Italian community was born. (Courtesy of Christine Corrado.)

The church of San Marco in Florence, Italy, is a beautiful example of the Italian baroque architecture that is often found across Italy. While not as large as the Gothic architecture used in many other churches built in Detroit during the late 19th and early 20th centuries, the pleasing form is warm and welcoming. While both San Francesco and Holy Family Churches were built in this style, only Holy Family remains standing in downtown Detroit along the Chrysler Freeway. Even in Italy, new churches are built in the modern style that predominates in North America.

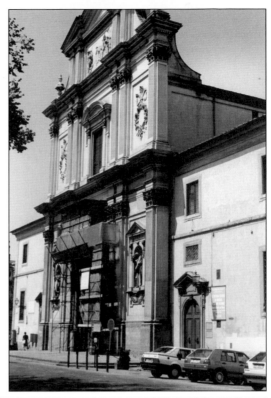

Santa Maria parish was founded in 1919 south of Henry Ford's Model T factory in Highland Park. The founders of the parish wanted a school to anchor the community, so the church was to be built in the future. That was not to be, though, because by the time the depression and World War II had ended, the parishioners began to move to the extremities of Detroit and into the suburbs. When the Chrysler Freeway was constructed in the 1960s, the church property was taken, and the parish disbanded. (Courtesy of the Archdiocese of Detroit Archives.)

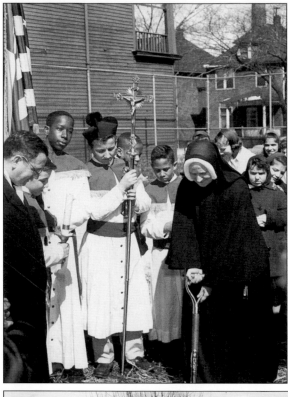

Santa Maria was the only parochial school in Detroit to be served by an Italian order of nuns, the Sisters of St. Dorothy. Here the mother superior breaks ground for the construction of a permanent convent. Unfortunately, changing demographics were to bring about permanent changes to the community. Not too many years later in the early 1960s, the school closed as the parishioners moved to the suburbs. The parish was finally closed in the 1970s. (Courtesy of the Archdiocese of Detroit Archives.)

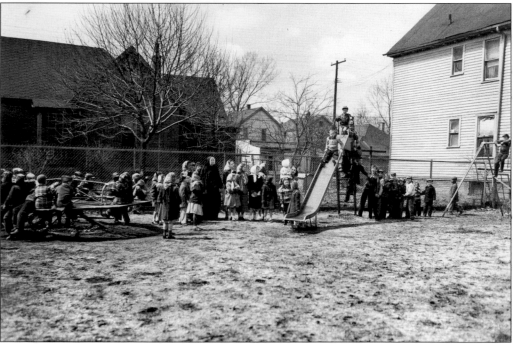

A sister and some mothers of students look on as Santa Maria's children play in the playground. Santa Maria was home to a number of mutual aids societies for immigrant families such as the Santa Maria Society. (Courtesy of the Archdiocese of Detroit Archives.)

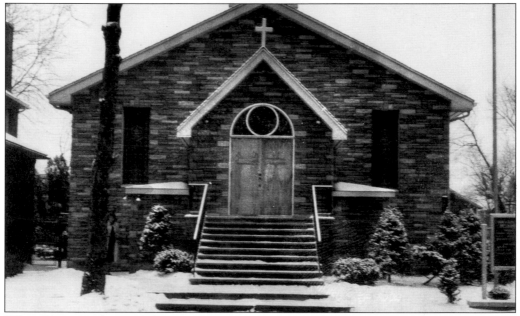

When Henry Ford opened the massive Rouge Plant in Dearborn, large numbers of people moved to southwest Detroit. Our Lady of Mt. Carmel parish was formed on Oakwood Boulevard, and this modest church was built to serve the increasingly scattered Italian community. While people from all parts of Italy were members, Sammarinesi from the small independent country of San Marino made up a large percent of the congregation. (Courtesy of the Archdiocese of Detroit Archives.)

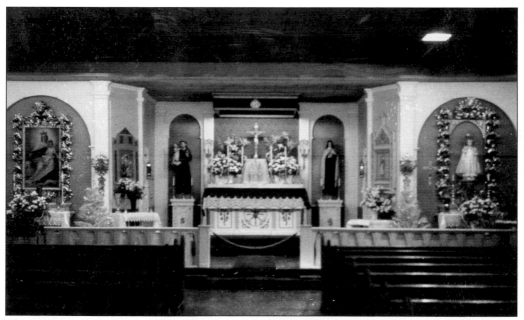

The interior of Mt. Carmel, like the exterior, is modest. The parish was threatened with closing in 1989 because of declining membership, but parishioners managed to rally to keep it open. Members living throughout the downriver area continue to support their church. (Courtesy of the Archdiocese of Detroit Archives.)

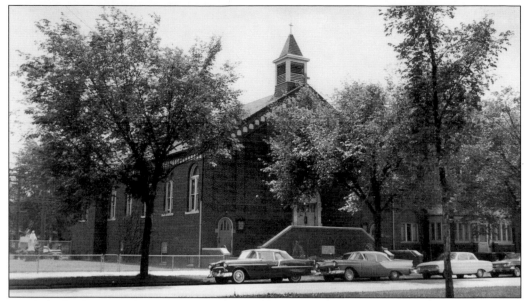

By 1926, another parish had formed to serve the Italians living west of Highland Park. The Church of the Madonna still exists on Oakman Boulevard. It is from this parish that Fr. William Cunningham and Eleanor Josaitis formed Focus Hope after the Detroit riots of 1967 to train Detroiters with skills to give them hope for employment and a prosperous future. Like several of the other Italian parishes, no parochial school was built. The children of members attended either public schools or nearby parish schools. (Courtesy of the Archdiocese of Detroit Archives.)

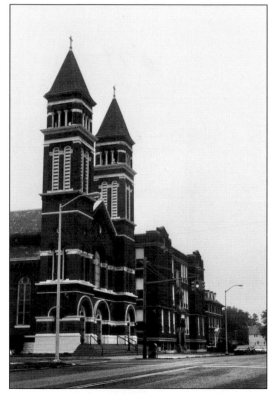

As the immigrant community grew, Italians moved north and east along Gratiot Avenue into former German neighborhoods. St. Elizabeth Church at McDougal and Canfield Avenues was one of several German parishes that incorporated many Italian Catholics into their congregations. The area south of Canfield became predominantly Italian by the late 1920s until the 1950s, when Italians moved farther north and African Americans settled there. The community also attracted many Polish immigrants on the streets north of Canfield.

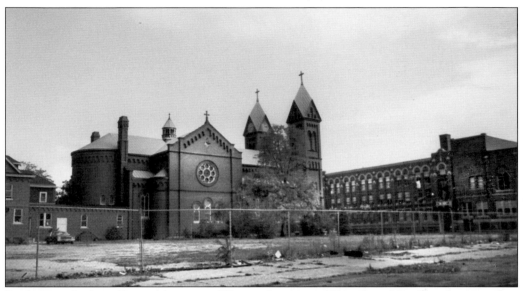

Farther north along Gratiot Avenue at Warren Avenue and East Grand Boulevard yet another German parish became home to many Italians and other nationalities. Built in the 19th century to accommodate the large German immigration, the parish welcomed the diverse nationalities that settled there. The School Sisters of Notre Dame also instructed students here. St. Anthony is now home to a predominantly African American congregation. The elementary school and convent were demolished in the 1970s, while the high school, renamed East Catholic High School, closed in 2005.

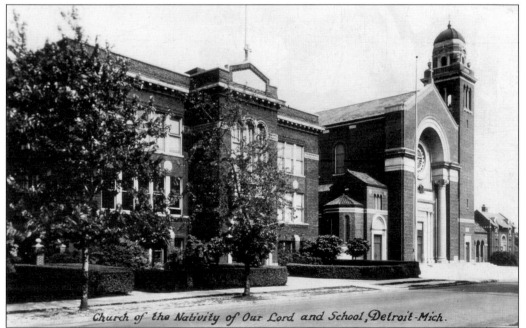

Church of the Nativity of Our Lord and School, Detroit-Mich.

The southern edge of the large Italian community known as Cacalupo, which centered at Gratiot and Harper, was part of Nativity parish and school. This beautiful Romanesque church remains open, but the school is closed. As the population grew, Italians in large numbers moved up Gratiot and either dominated or constituted a large minority of the members of many parishes.

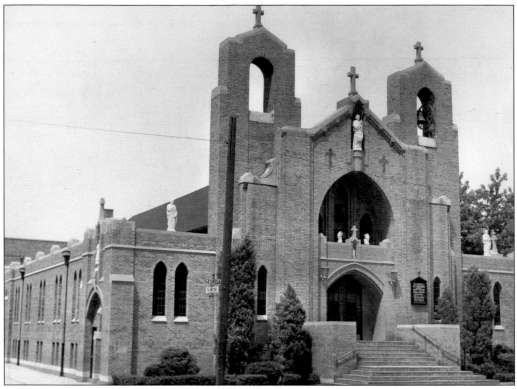

In the heart of Cacalupo was the parish named Patronage of St. Joseph. Its unique architecture incorporated elements of southwest colonial design with hints of Gothic and Romanesque features. While not founded as an ethnic parish, the majority of members were Italians until the 1960s. The parish lost members during the exodus from the city during the 1970s and was finally closed in the 1980s. For a brief period during the 1960s, San Francesco parish shared the facilities with the local parish. (Courtesy of the Archdiocese of Detroit Archives.)

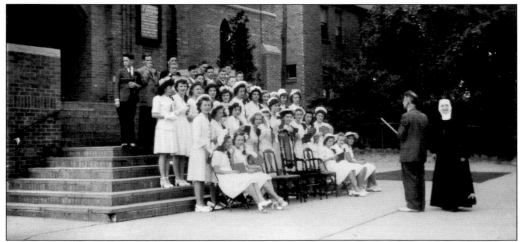

A confirmation class assembles on the church steps during the 1950s, when the parish was at its peak membership. There was no high school at the parish, though there was an elementary school. Patronage, as the parish was affectionately known, closed in the 1980s after its population had dwindled. (Courtesy of the Archdiocese of Detroit Archives.)

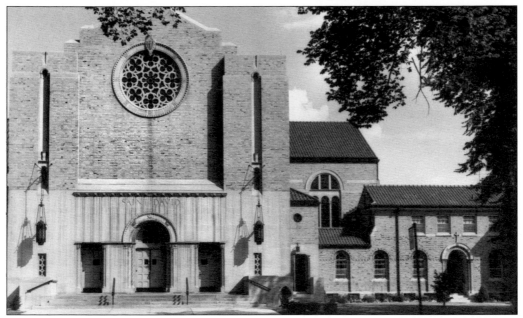

Further out on Gratiot Avenue at East Outer Drive was St. David's parish. With a large elementary school to serve the parish, it did not build a high school. A powerhouse in its heyday, this parish hemorrhaged members after the Detroit riots of 1967 and eventually was sold to an African American Protestant congregation. Sadly, it now sits abandoned. (Courtesy of the Archdiocese of Detroit Archives.)

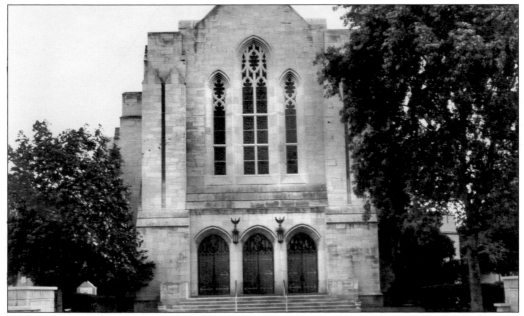

The oldest Catholic parish on the northeast side of Detroit is Assumption Grotto. Formed in the 19th century to serve a farming community, it saw tremendous growth from the 1920s until the 1960s. While it remained a multiethnic parish throughout its history, a large percentage of the members have always been Italian. Unlike many of the neighboring parishes in the city, Assumption Grotto has remained open into the 21st century and draws many members from their suburban homes.

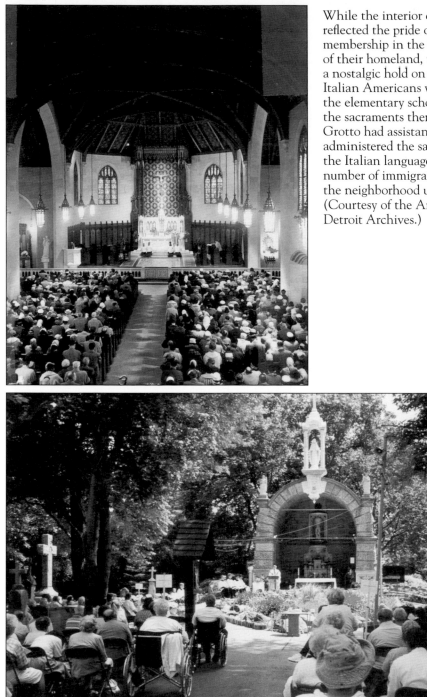

While the interior of the church reflected the pride of early German membership in the Gothic churches of their homeland, the parish has a nostalgic hold on thousands of Italian Americans who attended the elementary school or received the sacraments there. Assumption Grotto had assistant pastors who administered the sacraments in the Italian language for the large number of immigrants living in the neighborhood up to the 1970s. (Courtesy of the Archdiocese of Detroit Archives.)

For many Detroiters, the shrine attached to the church, patterned after the Grotto of Lourdes in France, remains a draw. On the feast day of the Assumption on August 15, many Italians return to Assumption Grotto to participate in the procession and other festivities honoring the Virgin Mary. Assumption Grotto is one of the few parishes in Detroit that continues to have processions and other traditional rituals on a regular basis.

Fr. Philip Bartoccetti, a leader in the forming of the Italian community in Detroit, celebrates his golden jubilee in the priesthood in 1951 at Our Lady of Consolation Church. Located where Lafayette Park stands today, this heavily Italian parish was demolished in the 1960s to build the residential high-rises at Lafayette Park. (Courtesy of the Archdiocese of Detroit Archives.)

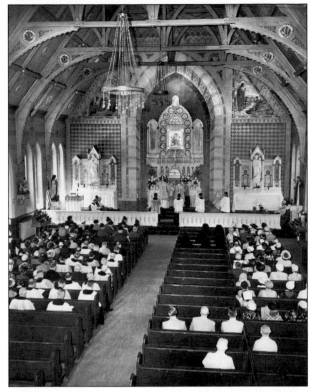

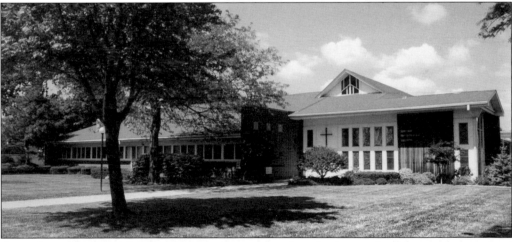

A number of Italians joined various Protestant churches. As the result of the steady growth of mission work among Italians, the Reverend Pasquale De Carlo came to Detroit in 1907 and became a leader not only of the small Protestant community but also of the Italian settlement. The First Italian Presbyterian Church's first building was on Sherman Street near Eastern Market. The church moved several times, evolving into the Faith Presbyterian Church that is located in St. Clair Shores. Reverend De Carlo had a tremendous influence on the growing immigrant community in Detroit. He founded the American-Italian Institute to assist immigrants assimilating into American society, supported the erection of a statue of Christopher Columbus to commemorate the Italian discoverer of America, and cofounded, with Vincent Giuliani, the *Italian Tribune of America* newspaper in 1909.

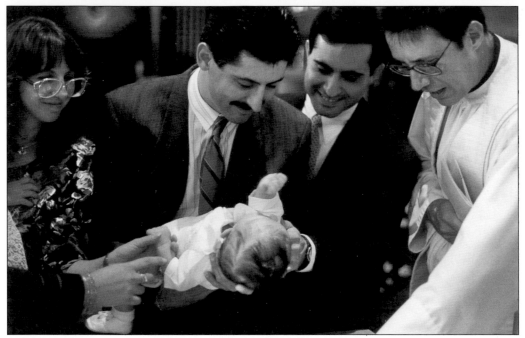

The rituals associated with milestones in life are important to the Italian family. Baptism is an initiation into the life of the community and the church and is celebrated with great joy. In addition, the choosing of godparents, the *comadre* and *compadre*, extends the family with honorary parents for the child. Anthony De Giusti holds his newborn son Nicholas at his baptism at St. Mary's Church in Wayne, Michigan, while Paul De Giusti, the godfather, and Anna, Nicholas's mother, look on. Parents and godparents refer to each other as *comadre* or *compadre*, the child calls his godparents *patrino* or *patrina*, and the godparents call their godchild *figlioccio*. This special recognition lasts a lifetime and is not taken lightly. (Courtesy of Sergio De Giusti.)

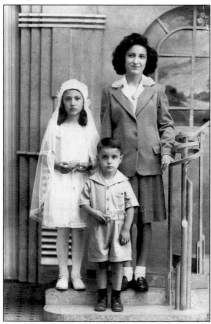

First Communion has always been an occasion to celebrate a child reaching the age of reason. A formal portrait was called for in the 1940s to send to the family back in Italy to show how the children were growing. Rose Delicato, dressed in her white finery, poses with her sister Antoinette and little brother Armando at the Valente Photography Studio on Gratiot Avenue in 1947.

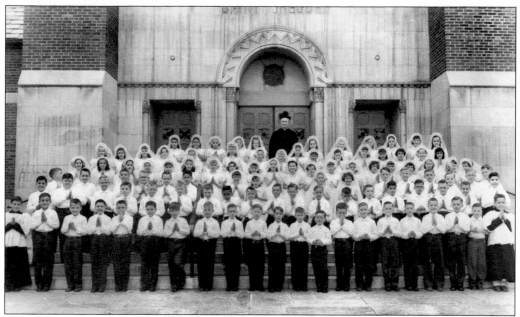

Some parishes recognized the young first communicants with a group photograph such as this one on the steps of St. Gregory's Church on the west side of Detroit. Among the children celebrating was Jenny Rossi, the American-born member of the Rossi family. While there were a number of Italian Americans among the group, the parish was multiethnic. (Courtesy of the Rossi family.)

Little Jenny Rossi, fourth from the left, participates in the May crowning of the Blessed Virgin Mary shortly after making her first communion. These church rituals added color and excitement for young Catholics and were—and remain—occasions for family celebrations. (Courtesy of the Rossi family.)

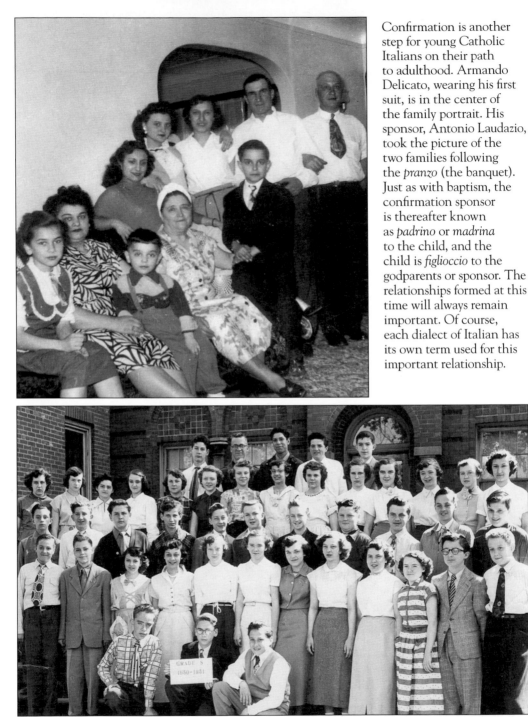

Confirmation is another step for young Catholic Italians on their path to adulthood. Armando Delicato, wearing his first suit, is in the center of the family portrait. His sponsor, Antonio Laudazio, took the picture of the two families following the *pranzo* (the banquet). Just as with baptism, the confirmation sponsor is thereafter known as *padrino* or *madrina* to the child, and the child is *figlioccio* to the godparents or sponsor. The relationships formed at this time will always remain important. Of course, each dialect of Italian has its own term used for this important relationship.

St. Anthony's 1951 eighth grade graduation class poses for a group picture before heading to high school. Many of the young people were of Italian descent, but many were not. There were no Italian parish high schools in Detroit, so young Italian Americans in both parochial and public schools learned with members of other nationalities, races, and religions. (Courtesy of Rose Riopelle.)

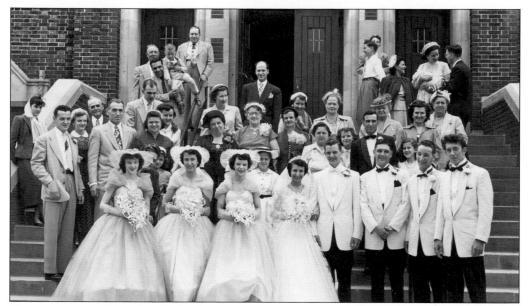

Continuing a tradition from Italy, the wedding guests stand for a group photograph on the steps of Epiphany Catholic Church after the wedding of Antoinette Delicato and Joseph Bye on June 13, 1953. Antoinette was born in Italy and her husband, Joseph, was born in the United States to Polish immigrants. By the 1950s, intermarriage had become common in the Italian community and would continue to increase in later years. As a result, a large percentage of young Italian Americans are proud of several heritages. (Courtesy of Antoinette Bye.)

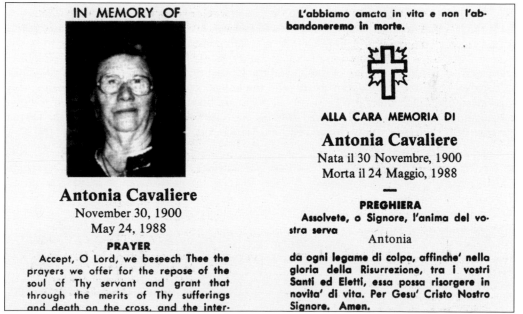

IN MEMORY OF

Antonia Cavaliere
November 30, 1900
May 24, 1988

PRAYER
Accept, O Lord, we beseech Thee the prayers we offer for the repose of the soul of Thy servant and grant that through the merits of Thy sufferings and death on the cross, and the inter-

L'abbiamo amata in vita e non l'abbandoneremo in morte.

ALLA CARA MEMORIA DI
Antonia Cavaliere
Nata il 30 Novembre, 1900
Morta il 24 Maggio, 1988
—
PREGHIERA
Assolvete, o Signore, l'anima del vostra serva
Antonia
da ogni legame di colpa, affinche' nella gloria della Risurrezione, tra i vostri Santi ed Eletti, essa possa risorgere in novita' di vita. Per Gesu' Cristo Nostro Signore. Amen.

At the end of life, religious rituals continue to offer comfort to the family. Antonia Cavaliere spent almost half of her life in Sant'Angelo, Italy, and the other half in Detroit. The prayer card is usually provided at funeral homes for the family and friends of the deceased so that they can readily pray for their loved one. In many cases the card is written in both English and Italian to accommodate the preference of the survivors. (Courtesy of the Cavaliere family.)

When Giuseppe Mistretta arrived in Detroit as Italian consul in 1990, he was impressed by the Detroit Institute of Art's collection of Italian masterpieces. The impressive array of sculptures and paintings is considered one of the best in the United States. Mistretta spearheaded a drive to improve the setting, and within six months, the Italians of Detroit had raised enough money to renovate the galleries and fund educational programs. Shown here in 1992, from left to right, cutting the ribbon to reopen the restored galleries, are Tony Bellanca, Giuseppe Mistretta, Detroit Institute of Art director Sam Sachs, and Richard Manoogian. (Courtesy of Sergio De Giusti.)

Four

THE ARTS

Italians and Italian Americans are justly proud of their many outstanding contributors to the world of politics, business, and science. However, they have particular pride in their accomplishments in the arts. Drama, literature, music, and the fine arts have a special imprint from Italian talent. The world's museums are full of examples of Italian creativity from ancient times to the present. This talent is not restricted to the Italians from the homeland and is also found among the diaspora. Italian Americans from Detroit take pride in the numerous members of their community that have achieved recognition locally, nationally, and internationally.

From the finest art in the collection of the Detroit Institute of Art to the world of opera, from the world renown Detroit Symphony Orchestra to the dance bands and even garage bands found across the metro area, Italians and Italian Americans have been tremendous contributors to our culture. The rich load of creativity found in this community has been incubated in the love of beauty that has been a foundation of Italian culture, even when poverty was a fact of life for so many immigrants. As a result, the evidence of this creativity is found everywhere. From the earliest immigrants, artisans and artists were among the members of the community. Detroit is proud to be the home of many outstanding works of art created by Italians in Italy and Italian Americans in America. The select group of creative geniuses honored in these pages is only a small cross section of the wealth of talent found in the Italian American community of this Detroit region.

In recognition of the legacy of Italian art in Michigan, Sergio De Giusti and the Italian Consulate in Detroit organized an all-inclusive testament to the works of Italian and Italian American artists in the state entitled *Patrimonio*. This exhibit took place at Wayne State University in 1996 and vividly illustrated the depth and breadth of the contributions of artists of Italian origin to Detroit and Michigan. Italians are justly proud of the magnificent contributions their compatriots have made and continue to make to the world of artistic expression. Many of the works shown in this book were part of this exhibit. (Courtesy of Sergio De Giusti.)

Born in Maniago in the Friuli region of Italy, Sergio De Giusti immigrated with his family to Detroit in 1954. His interest in the arts began in Italy and continued to grow at MacKenzie High School in Detroit and at Wayne State University, where he earned B.F.A. and M.F.A. degrees, majoring in sculpture. After teaching at the university and other institutions for a number of years, he left academia to concentrate on sculpture. The list of works he has created is long. Pictured here is the artist with a panel from the Michigan Labor Legacy Project, recently installed in Hart Plaza in downtown Detroit. (Courtesy of Sergio De Giusti.)

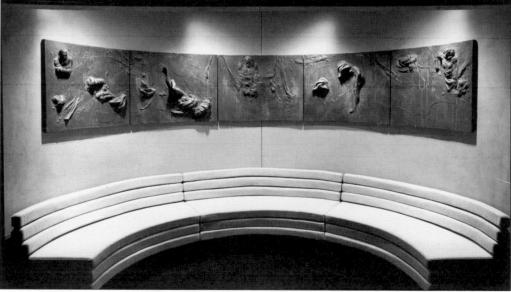

The State Library of Michigan commissioned De Giusti to do 20 panels for the rotunda of the Library and Archives Building of the state of Michigan in Lansing. These panels, pictured here, depict Michigan landscapes. De Giusti's work can be found in museums, churches, and public buildings in America and in Europe and include the cross used in Pope John Paul II's mass in the Silverdome in 1987 and the Bernini Triptych in the Italian Heritage Room at Wayne State University. (Courtesy of Sergio De Giusti.)

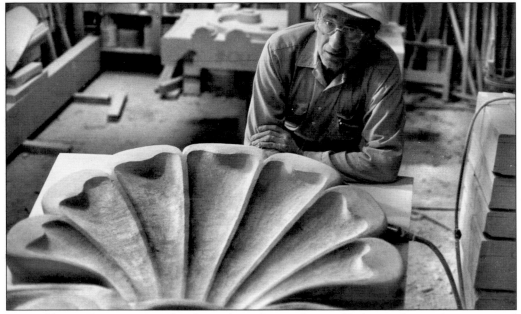

Pictured here is Francesco Acitelli, who works in the time-honored Italian tradition of stone carving. Born and raised in Detroit, he specializes in architectural embellishments found in columns, friezes, fireplaces, and furniture. Acitelli was born and raised in Detroit by immigrants from Assergi in L'Aquila, Italy. His work is found throughout Michigan. Acitelli is one of a long list of craftsmen from Italy who have enriched the cityscape of Detroit. (Courtesy of Sergio De Giusti.)

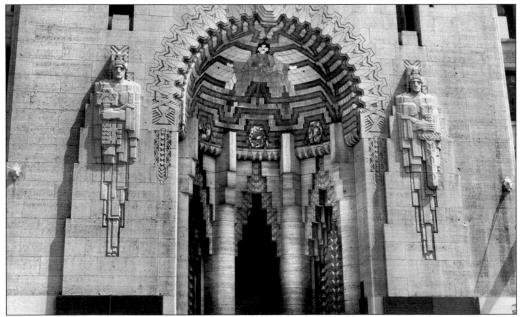

Corrado Parducci is one of the Detroit area's prominent architectural sculptors. His work is found in many of Detroit's public places, including the bears at the Detroit Zoo, the Rackham Reliefs at the University of Michigan, and the Stations of the Cross at the National Shrine of the Little Flower in Royal Oak. Pictured here are the limestone Mayan figures on the facade of the Guardian Building in downtown Detroit. (Courtesy of Sergio De Giusti.)

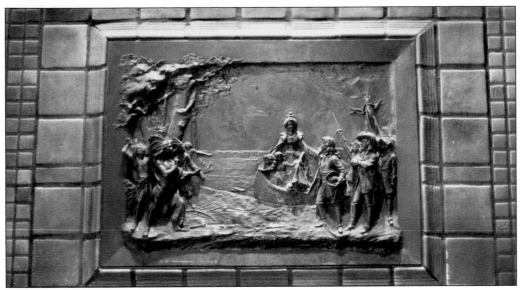

Carlo Romanelli was the son of Raffaello Romanelli and, like his father, an artist. Born in Florence in 1872, he moved to Detroit in the early 1920s. Romanelli was commissioned to produce a tablet for the original museum of art in Detroit. The bronze tablet depicts Madame de la Mothe Cadillac landing in Detroit to join her husband in 1702. This bronze is now incorporated into the Cadillac Center People Mover Station downtown. Romanelli produced a number of other works in the Detroit area, including *La Pieta* at the entrance to Mount Elliott Cemetery. (Courtesy of Sergio De Giusti.)

Diana Pancioli's family was from Montecatini in the province of Pistoia, Italy. Born in Detroit, she now resides in Ypsilanti, Michigan. A graduate of Wayne State University, she is a professor of ceramics at Eastern Michigan University. She is a designer and former director at Pewabic Pottery on Detroit's east side and has featured the unique tiles produced by the century-old firm in her creations. Among her most prominent works are the mosaic arches of the Cadillac Center People Mover Station. The colors and architectural design of these ceramic pieces make a functional space beautiful. She has published a book about ceramics entitled *Extruded Ceramics*. (Courtesy of Sergio De Giusti.)

Tom Fardello, also known as Tom Phardel, was born to immigrants from Palermo, Sicily, and raised in Detroit. A graduate of the University of Michigan and Wayne State University, he has been a faculty member at Pewabic Pottery and is the chairperson of the Ceramics Department at the Center for Creative Studies in Detroit. For the Times Square People Mover Station, he created a geometric pattern using Pewabic tiles with strong colors that are not typical of Pewabic but leave the rider with a sense of movement. Fardello is one of a large number of Italian American Detroiters to work in ceramics and one of three chosen to design stations for the Detroit People Mover. (Courtesy of Sergio De Giusti.)

David Rubello was born in Detroit to a family from Castellamare in Sicily and grew up on the east side. He first studied art at Cass Tech High School and won a scholarship to the Society of Arts and Crafts. He studied at the Academia delle Belle Arti in Rome and in Denmark before returning home to earn his M.F.A. from the University of Michigan. He was a design sculptor at the General Motors Corporation for many years and taught at a number of universities. Many people will recognize his mural on Washington Boulevard downtown, commissioned by the New Detroit Committee. He is shown here among his creations in his studio. Rubello has been instrumental in starting the archives at the Italian American Cultural Society and is currently archive director. (Courtesy of David Rubello.)

This statue of Christopher Columbus was moved to Jefferson Avenue and Randolph Street in 1987 from its original location in Grand Circus Park. The inscription reads, "Christopher Columbus, a great son of Italy. Born 1435 – Died 1506. Discovered America October 12, 1492. This monument is dedicated to his honor by the Italians of Detroit, October 12, 1910." Vincent Giuliani, the editor of the *Italian Tribune of America*, and Rev. Pasquale De Carlo, the minister of the Italian Presbyterian church in Detroit, initiated the project within the Italian community of the city. The artist, Augusto Rivalta, was so enthusiastic about his commission that he refused payment for his labors. (Courtesy of Sergio De Giusti.)

The General Thaddeus Kosciuszko Monument that sits on Michigan Avenue at Third Street is a work of Leonard Marconi. Marconi was of Italian and Polish descent and designed the statue in 1889 in Krakow, Poland. Kosciuszko was a hero of the American Revolution and of the Polish wars of liberation from Russian domination during the 18th century. This statue was a gift from the people of Krakow to the people of Detroit in 1976 in honor of the bicentennial of the American Revolution. (Courtesy of Sergio De Giusti.)

Sculptor Raffaello Romanelli from Florence, Italy, created the statue of Dante Alighieri that sits on Belle Isle in 1927. This statue honors the father of the literary Italian language, who, by writing his seminal work, *The Divine Comedy*, in Italian rather than Latin, established the basis for modern Italian. Its unveiling in 1927 came at a time when Italians were beginning to feel pride in their growing community in Detroit. The deterioration of the statue over the years led Italian societies in Detroit to raise funds to restore the statue in the 1980s. (Courtesy of Sergio De Giusti.)

A prominent, internationally known sculptor from Italy, Giacomo Manzu met Detroit architect Minoru Yamasaki, who commissioned him to complete sculptures for two of his Detroit buildings, the Michigan Consolidated Gas Company and the McGregor Conference Center at Wayne State University. This nude dancer is an eleven-foot bronze that Manzu modeled after his wife. It sits on a small fountain on the Jefferson Avenue entrance to the former gas company headquarters. Detroit is fortunate to have two examples of this great artist's work on public display. (Courtesy of Sergio De Giusti.)

Tony Spina was the first photojournalist to be inducted into the Michigan Journalism Hall of Fame. A world renowned photographer, he photographed popes, presidents, and other heads of state and leaders of society. Born in Detroit, he graduated from the Detroit Institute of Technology. During his 44 years at the *Detroit Free Press*, he received hundreds of awards—state, national, and international. In 1968, he shared a Pulitzer Prize the newspaper won for its coverage of the Detroit riots the previous year. Displayed in more than 80 exhibitions, his pictures are known for combining art and journalism. Here Spina (right) poses for a portrait with sculptor Giacomo Manzu. (Courtesy of the Walter P. Reuther Library, Wayne State University.)

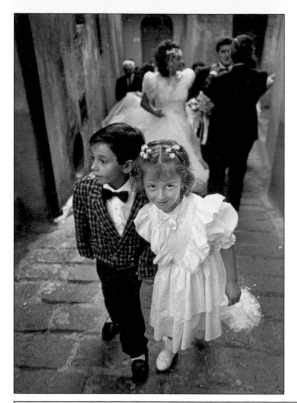

A prominent photographer whose family originated in Mandanici, province of Messina, Italy, Santa Fabio is a corporate/editorial photographer with a B.F.A. from Wichita State University. Born in Detroit, she has often visited her ancestral hometowns in Italy, where she took this photograph. This wonderful shot is of her cousin's wedding in Sicily, with the ring bearer and flower girl walking down a cobblestone street. (© Santa Fabio.)

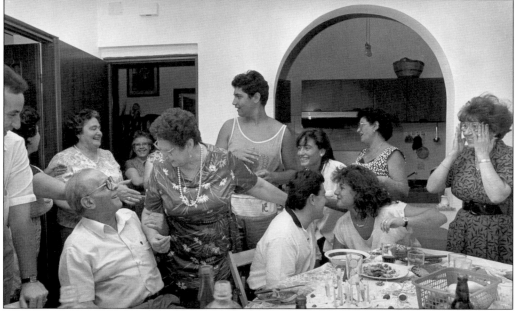

This photograph by Santa Fabio is an excellent encapsulation of the joys of being Italian. There is wonderful, lovingly prepared food, beverages, and family and friends sharing laughs and fellowship. The movement in the image shows a happy connection between people of different generations sharing a wonderful evening. Fabio's portfolio includes photographs used in many advertisements as well as studio portraits. (© Santa Fabio.)

Architect Harvey Ferrero's family came to America from Piemonte in Italy. He was born in Detroit and received his education at Lawrence Technical University. The Max Klein Building on Twelve Mile Road in Southfield is an example of his innovative talents. The building roused the ire of some traditionalists but won a prize for Ferrero from the American Institute of Architects Detroit Chapter the year it was completed. (Courtesy of Sergio De Giusti.)

Gino Rossetti is the son of an architect and the father of one. The firm of Rossetti Associates Architecture was founded in 1969 and includes offices in Birmingham and Los Angeles. Large numbers of Detroiters work, shop, and play in buildings designed by Rossetti's firm. Ford Field, the home of the Detroit Lions, Compuware World Headquarters, Wayne State University's welcome center, and the Ford Motor Company's office buildings, known affectionately as the "washer and dryer" in Dearborn, are a few of the firm's buildings. Gino Rossetti is shown with a mock-up of the towers he designed for Ford Motor Company in the 1960s. He is proud that his son, Matt, is a third generation architect. Matt is now president of the firm. (Courtesy of the Walter P. Reuther Library, Wayne State University.)

This painting, *Six Virgins and One Magdalene,* was painted by Debra Bosio Riley, a mixed-media artist who was born and raised in Detroit in a family that originated in Teramo, Italy. She is a graduate of Wayne State University and has an M.F.A. from Vermont College of Norwich University. The Renaissance-style painting of women is done in oil on vintage ironing boards. (Courtesy of Sergio De Giusti.)

A large number of Italian American artists come from families that originated in Sicily. One of them is a prominent painter and printmaker named Frank Cassara. The Cassara family is originally from Partinico, province of Palermo, and he now lives in Ann Arbor, where he is professor emeritus of art at the University of Michigan, from which he earned his M.F.A. This painting, *Water As Destructive Element,* is an example of his large-scale work. (Courtesy of Sergio De Giusti.)

One of the most colorful figures in the art community in Michigan is Silvio Barile. He was born in Ausonia, province of Frosinone, and now resides in Redford. A baker by trade, he constructs sculptures from found items and displays them in his bakery and studio on Plymouth Road in Redford. Barile is the second from the right among his many friends who are admiring his work. (Courtesy of Sergio De Giusti.)

On Metropolitan Parkway in Sterling Heights is a sight many people brake and twist to view. The grounds of Bernardo Puzzuoli's house are heavily decorated in concrete ornaments. Statues, flowers, spinning decorations, Virgin Marys, and even a windmill decorate the entire yard. An immigrant from Italy by way of Windsor, Puzzuoli has dedicated his artistic creation to his late wife, who died in 1989. The Detroit media delight in highlighting his art for the community. While controversial to some, Bernardo Puzzuoli's creative garden is a work of art to many. (Courtesy of Sergio De Giusti.)

A warm, old country feeling greets shoppers as they enter Cantoro Market in Livonia. The odor of bread and spices and the colors and shapes of the merchandise are complemented by the beautiful murals on the walls created by Dennis Orlowski that are scenes from Cassino, Italy, the hometown of the owners, Mario and Pat Fallone. The customers feel that they are in an Old World marketplace, meeting friends and neighbors while purchasing their Italian grocery products. A love of beauty inspired the Fallones to brighten their place of business. (Courtesy of the Fallone family.)

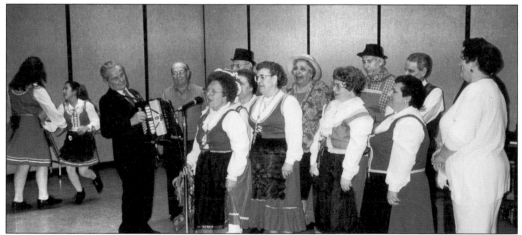

Genoveffa Torrice Capaldi came to Detroit with her family from the Ciociaria area south of Rome. While raising her family, she organized a women's choir, the Campagnole di Cassino, to sing the songs that they loved. They have sung at religious shrines throughout the Midwest and Canada and have visited nursing homes and performed at festivals. Today the chorus includes men. Capaldi is shown here at the microphone, and her granddaughters are dancing in the background. She made the costumes the women are wearing. Groups like the Campagnole di Cassino help keep folk culture alive among Italian Americans. (Courtesy of the Italian Study Group of Troy.)

David DiChiera is one of Detroit's cultural icons. His impact on the musical life of the city and on the city's revitalization is enormous. The fifth child of Cosimo and Maria DiChiera from Caulonia, Calabria, he was born in Pittsburgh and moved with his family to Los Angeles when he was 10 years old. Growing up, he pursued an interest in music, earning a doctorate at UCLA. At 24 years of age, he went to Italy on a Fulbright Scholarship to study music and became even more enamored of Italian culture. Fortunately for Detroit, he was hired by Oakland University in 1962 and began his involvement in the operatic life of the city. (Courtesy of David DiChiera.)

Overture to Opera, founded by David DiChiera, was originally formed to prepare audiences in the Detroit area for the arrival of the Metropolitan Opera's annual visit in the 1960s and 1970s. As the organization grew, DiChiera guided its growth into the Michigan Opera Theatre, which is now one of the top American opera companies. Eventually his involvement in developing a Detroit opera company became a full-time passion, and he left Oakland University. As audiences grew, the company sought new venues in which to present the opera seasons. From performing at the Music Hall, the Fisher Theatre, and the Masonic temple, the company realized it needed its own home. (Courtesy of David DiChiera.)

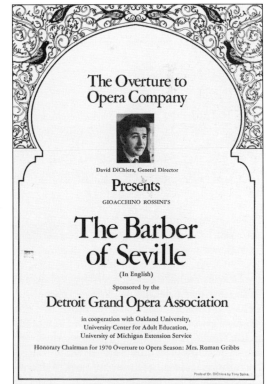

The Overture to
Opera Company

David DiChiera, General Director

Presents

GIOACCHINO ROSSINI'S

The Barber
of Seville

(In English)

Sponsored by the

Detroit Grand Opera Association

in cooperation with Oakland University,
University Center for Adult Education,
University of Michigan Extension Service

Honorary Chairman for 1970 Overture to Opera Season: Mrs. Roman Gribbs

Photo of Dr. DiChiera by Tony Spina.

Combining his love of music with his love of his adopted hometown, David DiChiera pursued a dream of renovating an abandoned movie palace downtown. Against many obstacles, the old Broadway Capital was purchased and renovated into a marvelous home for grand opera in which any city in the world would be proud. Seen here is a "before" picture indicating what tremendous faith was required to see past the obstacles. With the completion of the Detroit Opera House in 1996, the downtown neighborhood surrounding the building also began an amazing rebirth. The Detroit renaissance is due in large part to visionaries like David DiChiera. (Courtesy of David DiChiera, photograph by Liang Photography.)

Detroit was a stop on Carmine Coppola's journey to fame as a musician. He and his wife, Italia, lived in Detroit for several years in the 1930s during the Depression, when he was a flautist for the Detroit Symphony Orchestra and played on the Ford Symphony Hour radio show. He went on to be the first flautist for Arturo Toscanini in the NBC Orchestra and later composed music, including theme music for films. While in Detroit, Coppola's second son was born at Henry Ford Hospital and was named Francis Ford Coppola. The middle name was in honor of Henry Ford for giving Carmine Coppola work during the Depression. Francis Ford Coppola went on to become one of the foremost directors in Hollywood and is especially proud of *The Godfather* trilogy. Carmine is shown here playing pool, holding the cue, in the Detroit Federation of Musicians Club Room. (Courtesy of the Walter P. Reuther Library, Wayne State University.)

The Italian Colonial Band was formed in 1902 to serve the Italian community at religious and secular events. In 1973, the band was reorganized by Guido Fucinari to play for the closing of Santa Maria Church. Since then, under his direction, it has played concerts and parades in Detroit and Canada. Fucinari was born to a family that emigrated from Atina in central Italy to Detroit. A graduate of Cass Tech High School, where he majored in music, he went on to study woodwind instruments with several prominent musicians in Detroit and New York. Fucinari was the president of the Italian Study Group of Troy from 1984 until his death in 1986. He was dedicated to music, the Italian American community of Detroit, and, especially, to his wife Florence, his five children, and his brother and four sisters. (Courtesy of Rose Fucinari Vettraino.)

In 1973, the Detroit Symphony Orchestra brought Aldo Ceccato from Italy to be its conductor. He also conducted the symphony at the Meadowbrook Festival in Rochester, Michigan. Born in Milan, he studied at conservatories in Italy and other European countries. His tenure in Detroit was short, and he went on to lead the orchestra in Hamburg, Germany, in 1977. He was not the first Italian to conduct the Detroit Symphony. In 1936, Franco Ghione arrived in Detroit to replace the founding conductor, Ossip Gabrilovich, but since his forte was opera and he did not speak English, he returned to Italy after four years. (Courtesy of the Detroit Symphony Orchestra Archives.)

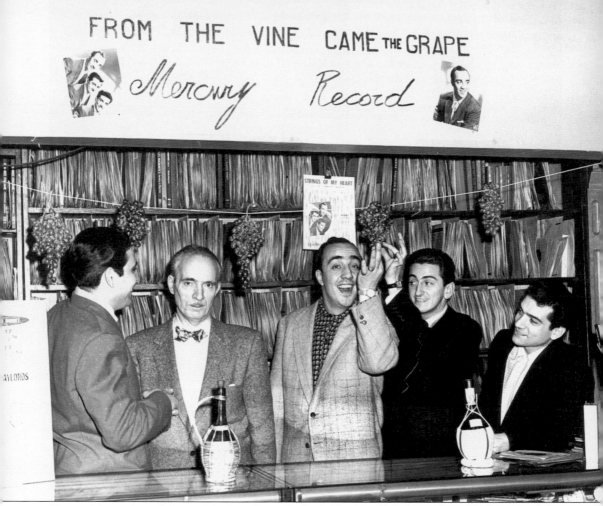

Pictured here, from left to right, are Ron Gaylord (Fredianelle), Luigi Bonaldi (owner of the store) Burt Holiday (Bonaldi), Billy Chris, and Don Rea at the counter in Burt's father's store, Bonaldi's, on Gratiot Avenue in the 1950s. The quartet known as the Gaylords (everyone seen here except Luigi) were a hugely popular success, receiving four gold recordings in the 1950s including the following: *Tell Me Your Mine, From the Vine Came the Grape, Isle of Capri,* and *The Little Shoemaker.* They performed on national television and made numerous commercials, including the longest running commercial of all-time *Roy O'Brien's Got Them Buying,* recognizable to any Detroiter over 50. The group wrote and performed a family musical entitled *Famiglia* about growing up in Detroit. The Gaylords have popularized Italian music among many Americans. (Courtesy of the Bonaldi family.)

One of America's best-known entertainers from the 20th century was a singer and actor named Johnny Desmond, known in Detroit as Giovanni Alfredo de Simone. Born in Detroit to immigrants from Sicily, Giovanni grew up on the east side and graduated from Northeastern High School. At age 11, he was singing while helping out in his parents' store when a customer remarked that he should audition for a talent show on the radio. He won the contest and began his career. After high school, he attended the Detroit Conservatory of Music and then left for New York. He sang with the Gene Krupa Orchestra and, while serving in the armed forces during World War II, joined the Glenn Miller Orchestra, spending most of the war entertaining troops. Broadway shows and films followed, but Johnny Desmond will always be remembered most for his beautiful voice and his hit songs, such as *I'll Walk Alone* and *It Had to be You*. (Courtesy of David Rubello.)

Detroit can be proud of its musical heritage. Not only has classical music thrived, with the Detroit Symphony, the Michigan Opera, and numerous chamber groups, but the city has always been a center of popular music. Soul music, exemplified by the tremendous popularity of Motown, is closely identified with the city. So are country music, hip-hop, electronic, and garage rock groups. Young Italian Americans are often found among these groups. The winner of the 2003 Detroit Music Awards for outstanding rock artist/group was a band called the Paybacks. Marco Delicato, a third generation Italian American, plays lead guitar in this photograph with Wendy Case singing. (Courtesy of Marco Delicato.)

79

The Italian community in Windsor grew steadily in the 1920s and 1930s, and people petitioned their bishop to have a parish of their own. In 1938, Fr. Constantino DeSantis came from New Jersey to organize it. With some assistance from the Benedictine Fathers from Detroit, Father (and later Monsignor) DeSantis guided the parish as it grew, building, and later enlarging, the church to meet the needs of a rapidly growing community. St. Angela Merici was built through the time and skills of its many parishioners who were familiar with construction work. Dinners, dances, movies, bingos, and parties were the source of money for materials. The parish provided for the spiritual needs of the people and served as a community center for immigrants. The Sisters of the Holy Family arrived in 1963 to assist the Scalabrini priests, who replaced Msgr. DeSantis when he retired. St. Angela has been the heart of the Italian community on Erie Street for many years. The new community center, under construction in the background, evidences its continuing commitment to Italian Windsor.

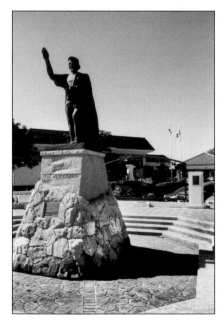

Greeting visitors to the Caboto Club is this statue of Giovanni Caboto, also know as John Cabot, the Italian explorer hired by the king of England to find a sea route to China and to claim as much of the New World for England as possible. The Italians who organized the club were honoring a famous Italian explorer and reaffirming the historic role Italians have played in exploring North America.

Five

WINDSOR

The history of the Canadian city of Windsor closely parallels that of Detroit. The cities were united in New France and under the British until the Revolutionary War divided them between two separate nations. Until recently, passing through customs was perfunctory, and residents shopped, worked, and lived as though the border did not exist.

The first Italians in Windsor, as in Detroit, were the family of Alphonse Tonti, 300 years ago. While other Italians made Windsor their home, they were few, and often used French or English versions of their names.

The 20th century witnessed the arrival of mass emigration from Italy to both Detroit and Windsor. As Detroit became the center of automotive manufacturing, Windsor assumed that role in Canada. Opportunities in Canada created the same draw as those in Detroit. On the American side, mass migration occurred in the early years of the century. In Windsor, however, the greatest number of Italians arrived after World War II, even as their American cousins were assimilating and moving away from the traditional neighborhoods. Clustering around the community center surrounding St. Angela Merici Church, the Italians created a "Little Italy" that has grown in popularity into the 21st century. There are a growing number of shops selling groceries, jewelry, clothing, and gifts. The presence of magnificent restaurants has made Erie Street East, known as Via Italia, a magnet for visitors. The clubs and organizations that support Italian identity in Windsor count many Americans as members and participants. Indeed, many families have members on both sides of the Detroit River.

By the end of the century, both cities had experienced an end to large-scale emigration from Italy. In each city, more and more young people have been marrying partners not of Italian origin. Also, in both cities, urban sprawl has dispersed Italians to distant areas. The Italian cultural presence in Windsor has been able to maintain its identity more easily than in its sister city due to the success of the Erie Street center for church, social, and civic festivities and the thriving businesses and restaurants. Fortunately for both cities, proximity to each other has enriched both communities. Celebrations bring people from both sides of the river together in fellowship. Italian identity is enriched by interaction between residents of the United States and Canada and endures because of it.

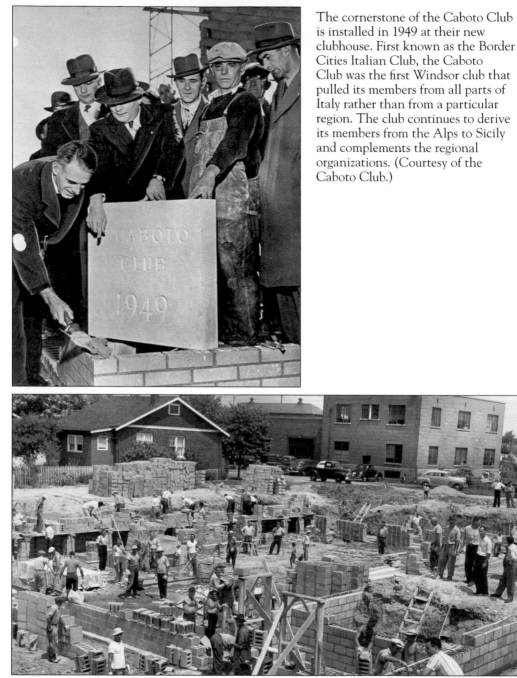

The cornerstone of the Caboto Club is installed in 1949 at their new clubhouse. First known as the Border Cities Italian Club, the Caboto Club was the first Windsor club that pulled its members from all parts of Italy rather than from a particular region. The club continues to derive its members from the Alps to Sicily and complements the regional organizations. (Courtesy of the Caboto Club.)

This photo of the construction of the Caboto Clubhouse in the 1940s is a good example of the community spirit that infuses the Italians of Windsor. Workers are members using weekends to donate their expertise and muscle to build their center. Since many men in the community worked in construction, their expertise was available to cut costs and to participate in the advancement of their club and the Italian community in Windsor. The large banquet hall was included in the design of the building for club events as well as to rent out to members or the community for meetings and receptions. (Courtesy of the Caboto Club.)

The Caboto Club, like most clubs until the 1950s, had separate men's and women's groups. This picture shows the executives of the Women's Auxiliary of the club in 1955. They include, from left to right, (first row) M. Faranti, L. Camilotto, E. Fabris, I. Rocca, C. Bosetti, S. Marcocchil, and F. Scondelaro; (second row) F. Lenardon, V. DelCol, P. Introcasso, M. Vendrasco, M. Gasperini, S. Gasparet, and A. Pistor. Separate groups are no longer part of the organization, reflecting the changing times. Men and women work together in running the club. (Courtesy of the Caboto Club.)

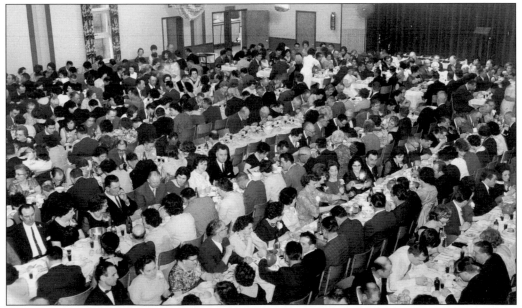

Italian culture holds good food and wine in high regard. Celebrations inevitably include wonderful meals consisting of Italian specialties. This celebration at the Caboto Club in the 1960s shows a well-dressed crowd at a club event. Most organizations have gatherings several times a year so that members can enjoy good food and good company and maintain ties to friends and family. (Courtesy of the Caboto Club.)

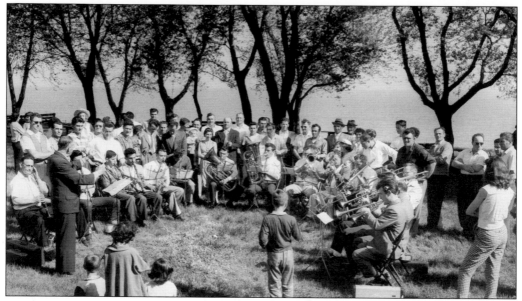

Combining a rehearsal with the chance to have a picnic by the shore of Lake Erie on a summer weekend, the Italian Band sponsored by the Caboto Club plays for friends and family in an informal concert. Many large organizations sponsor groups like this one to entertain at formal occasions or to represent the organization at civic events. Among many older immigrants, the music they remembered from their youth has been another connection to the old country. (Courtesy of the Caboto Club.)

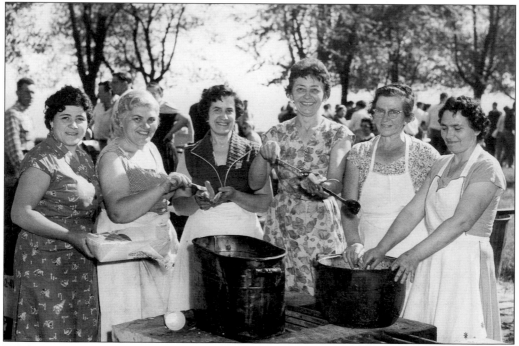

While a picnic outing is a good time to relax and enjoy the outdoors, someone needs to do the cooking. This group of women seems to be enjoying preparing lunch for a Caboto Club outing in the 1950s. (Courtesy of the Caboto Club.)

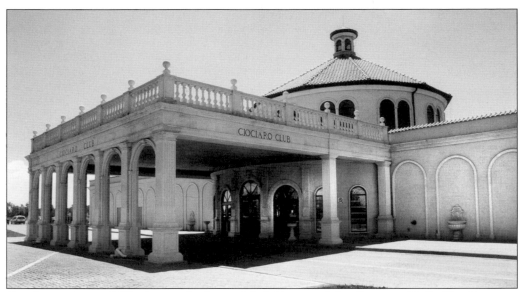

On the outskirts of Windsor is the beautiful clubhouse of the Ciociaro Club. The Ciociaria is south of Rome and north of Naples in the province of Frosinone. The large population of immigrants from this region decided in 1972 to build this monument to show their love of their homeland. It is a testament to their belief that their descendants will always have affection and ties to their hometowns in this region of Italy. As with many other clubhouses for Italian organizations, rooms are rented for meetings and receptions to help pay for the expenses of maintaining the buildings.

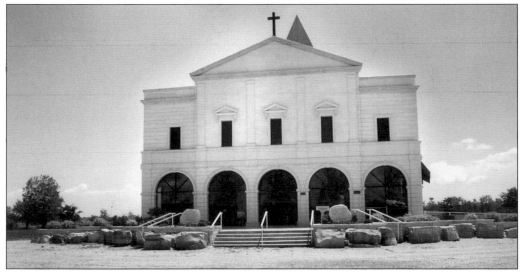

A unique feature of the Ciociaro Club grounds is the re-creation of an ancient shrine in the mountains flanking the Comino Valley that is dedicated to the Madonna of Cannedo. Care was given to reproduce the church as a duplicate of the one in Settefrate, province of Frosinone. Open to the public every Sunday, it is the site of religious devotions during the year, especially in August during the feast of the Madonna of Cannedo, when masses, a procession, and a festa are celebrated and people come to Windsor from Ontario and the American Midwest to join in the religious observance and the celebration that follows. In this way, folk customs of Italy are preserved for generations of Italian Canadians and their American cousins.

Designed and built by Luigi DeZan, the entrance to the Fugulor Furlan Club in Windsor has a traditional furlan, a metal pot used on the hearth that is the center of family life in the region of Friuli. Friuli is in northeastern Italy, bordering Austria, Slovenia, and Croatia. In 1966, the first building was erected through the efforts of a group of people determined to re-create in North America the community spirit found in their homeland. The large community of Friulani in Windsor and Detroit celebrates their heritage through membership in this club. Traditional holidays are acknowledged, and food, dances, and conversation in their own language are enjoyed at club activities.

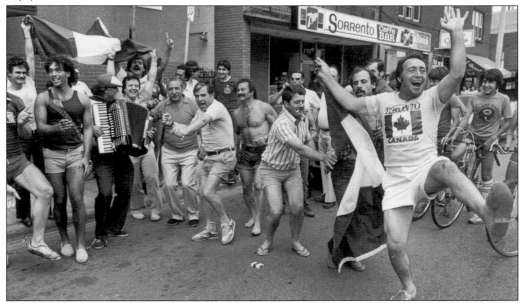

Demonstrating that the ties to Italy are strong and deep, this exuberant crowd celebrates Italy's victory in the World Cup in July 1982. Accordionist Elio Palazzi leads an impromptu street dance outside Windsor's Sorrento Cafe on Erie Street. The burst of pride and happiness is evident in the participants. Windsor's coffee shops, restaurants, and bars often have Italian sporting events on television so that people can keep up with their favorite teams from back home. (Courtesy of Tim McKenna, *Windsor Star*, Windsor Community Museum, P10809.)

In 1958, Gianni Sovran and his nephew Ezio Orlando worked to re-create in Windsor a version of the *Giro d'Italia* bike race that is held annually in Italy. A 1.7-kilometer course was plotted on Erie Street and surrounding streets, the Windsor City Council gave approval, supporters from Windsor and Detroit pulled together, and the race, called "The Tour of Windsor," took place. Attracting participants from many communities, the popularity of the race continues to grow almost 50 years later. This picture shows cyclists lined up outside St. Angela Merici Church, ready for the 1964 race to begin. (Courtesy of St. Angela Merici Church, Windsor Community Museum, P10522.)

Maintaining Italian culture in a distant place requires some work and, in this case, a lot of fun. Members of the Regis Club dance the tarantella at a performance at St. Angela's Parish Hall. Young people are encouraged to dress in folk outfits and learn dances and songs that reflect their parents' Old World homeland. In Windsor, as in all Italian communities around the world, keeping the younger generation interested in their heritage is a top priority. (Courtesy of St. Angela Merici Church, Windsor Community Museum, P10518.)

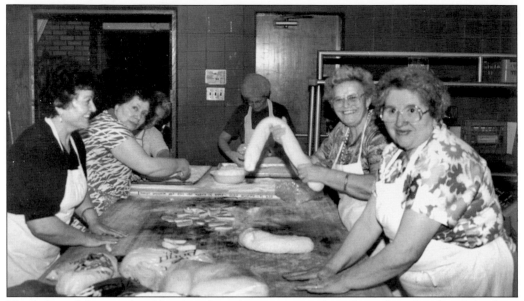

The ladies of the parish of St. Angela gather to prepare for a festival in the church kitchen. Making ciambelle, a traditional ring-shaped pastry popular among Italians from many regions, from left to right, Flora Ghione, Maria Di Giacomo, Angela Di Domenico, Adelaide La Posta, Maria Massara, and Filomena Vitale enjoy themselves as they work for the church fund-raiser. A good deed and fellowship are the rewards for their hard work. (Courtesy of St. Angela Merici Church, Windsor Community Museum, P10546.)

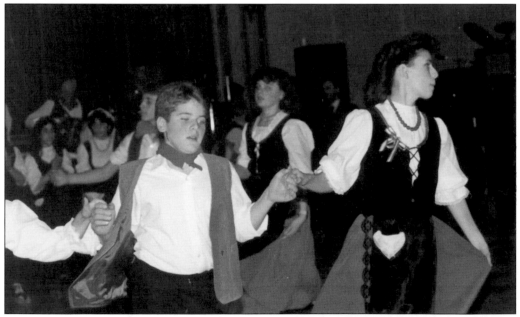

John Lopez (left) and Domenica Savoni, members of the Geloso folk dancing group, dance at the Ciociaro Club in 1987. By encouraging young people to join groups like this one, parents insure that their children will be familiar with their ancestral heritage. Many young people combine language classes with folk dancing or craft making at the various clubs and community centers. (Courtesy of Caterina Lopez, Windsor Community Museum, P10641.)

Until recently, many Italians made their own wine at home every fall. This picture shows the family of Maria Carriero at work in the 1960s. Usually using grapes imported from California, immigrants and their descendants on both sides of the border re-created traditions from their youth. Basements often had wine cellars where the wine and winemaking equipment was stored. The photograph shows that, while the work was hard, knowing that they had produced their own wine was very satisfying. Notice the traditional hand-cranked grape crusher on the barrel. (Courtesy of Maria Carriero, Windsor Community Museum, P10830.)

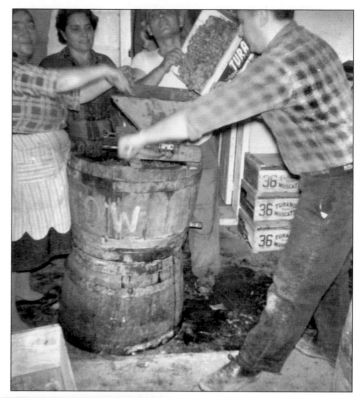

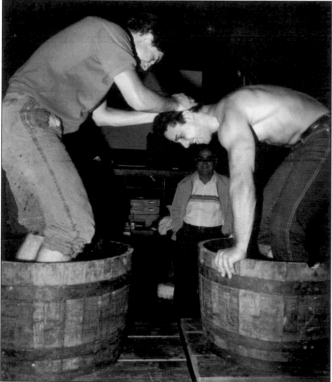

While some people continue to insist on homemade wine, more often winemaking today is an occasion of fun and reminiscence. The family's supply of wine is usually purchased at the wine shop. This picture shows the grape-stomping contest on opening day of the Grape Festival at the Caboto Club in 1984. Jim Cricioto uses Dan Wiseman's head for balance during their 60-second stomp. (Courtesy of the *Windsor Star*, Windsor Community Museum, P10808.)

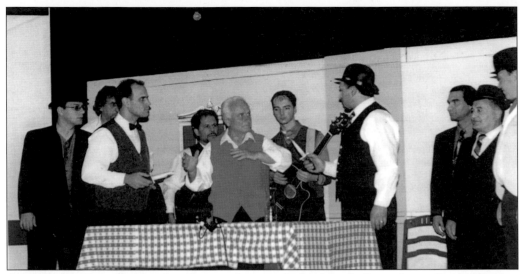

Armando Viselli and his brother Carmine have worked to keep Italian culture alive in Windsor and Detroit by writing and producing plays and dramatic reenactments in the community. In 2003, they were instrumental in organizing a Good Friday passion play on the grounds of the Ciociaro Club. It includes the Stations of the Cross and grows in popularity each year. Their work has appeared on television and the radio on both sides of the border. Pictured above is a scene from their play, *La Passatella*, put on by Il Comitato Dell'arte e Cultura del G. Caboto Club in 1999. Armando Viselli (center of table) appears in this scene with a few of the 66 cast members. (Courtesy of Armando Viselli, Windsor Community Museum, P10879.)

The blocks of Erie Street East are lined with restaurants, bars, bakeries, grocery stores, and hardware and jewelry stores that serve the neighborhood's needs. They also attract large numbers of Americans—Italian and non-Italian. The ambiance of Via Italia, as Erie Street is also known, attracts many people to shop and eat or to just enjoy la dolce vita. This corner, across from St. Angela's Church, has a nightclub and two restaurants that appeal to a cross section of people from both sides of the border.

90

There are approximately 15 restaurants on a five-block stretch of Erie Street and several others farther along. Interspersed are stores that provide residents with the necessities, and some luxuries, of life. Because of its quaint villagelike atmosphere, Via Italia draws many people who want to enjoy the Italian atmosphere of the neighborhood. Authenticity is what makes this area so pleasant and what continues to draw many people, especially when a festa is in progress.

A bar in Italy is usually more what Americans and Canadians would refer to as a coffee shop. Here people congregate during the day as well as all evening to enjoy a cup of espresso, a biscotti, and the company of friends. The outside seating on warm evenings is crowded with people enjoying good conversation and refreshments. Its compactness lends itself to the traditional *passegiata*, the evening stroll, practiced throughout Italy. Since Detroit no longer has a similar Little Italy, the Erie Street neighborhood attracts a large number of Italian Americans who crave a taste of home. The street is less than 10 minutes away from downtown Detroit and, therefore, is a popular destination.

Vittorio Re, pictured with his wife, Catherine, has been an influential leader of the Italian community for many years. A member of Italy's Foreign Service, he came to Detroit to reopen the Italian Consulate in 1947, after having served in Yugoslavia and Australia. He ran the consulate for 30 years, dealing with the incredible complexities of reuniting families, clearing titles for destroyed properties in Italy, and repairing relations between the United States and Italy. Choosing to remain in Detroit after retirement, Re has written a number of historical monographs and some fiction. He has also been a member of a number of organizations, including the Michigan Historical Society and the American Italian Historical Association. He remains active in the pursuit of Italian and American studies. (Courtesy of Vittorio Re.)

Six

PEOPLE

Many years ago, Voltaire said, "There is nothing common about the common man." The validity of this statement becomes apparent when attention is given to the Italian immigrant to Detroit. From the well-educated professional to the mass of poor sharecroppers, these people demonstrated an amazing resilience. Most of them had experienced poverty and hunger and hopelessness in Italy, which drove them to endure a long, uncomfortable trip across an often stormy ocean to a strange land. The alien culture that greeted them on their arrival was often indifferent to their fears and suffering. While the earliest arrivals had the most difficult time adjusting, it remained a troubling experience throughout the period of emigration to America. Making a living was paramount to the immigrant's experience in America. Finding a comfort zone, supporting a family, and realizing one's potential were goals that drove the immigrants' lives. For many, the fruit of their labor was a life of satisfaction, knowing that they had removed their families from poverty and had provided hope for a fulfilling future in their new country. The second generation often was able to stretch to meet the challenges and opportunities America had to offer. Every Italian American has a story of obstacles overcome and opportunities seized. Some people managed to achieve national and even international recognition and have become a source of pride to all. The majority of people have not been recognized in newspapers or on television but have led exemplary lives nonetheless that are a tribute to themselves, their families, and their community. While Italian ancestry has not been a guarantee of satisfaction in life, it has served as a source of strength that has encouraged the pursuit of success in the outside world while providing the security of strong family support combined with loyalty to friends and the acceptance of hard work and dedication in achieving life's goals. The people highlighted in the following pages are a representative sampling of the Italian American community. Hundreds of thousands of others also have lives that are inspiring. Virtually everyone has an interesting story to tell.

Born in Brooklyn, Luella Sirianni Baron was a pillar of the Italian community in the Detroit area. Proud of her Italian American heritage, after her marriage to Deino Baron, she visited and fell in love with Italy and dedicated her life to preserving and encouraging the appreciation of Italian American culture. A devoted wife and mother in a family that included a special needs son, Luella created the Special Performing Arts Group of Troy to encourage special needs adults to participate in the arts and is a part of the Italian Study Group of Troy. The Italian Study Group of Troy sponsors language classes, folk dancing, choral singing, and a children's ensemble, among many other activities. Luella is shown giving an award to Sergio Nascimbeni at Festa Italiana. Luella Sirianni Baron died in 1994, but her life's work continues through the organizations she founded and the inspiration she has passed on to love Italy and America. Her life and example embodied the best of both. (Courtesy of the Italian Study Group of Troy.)

Dr. Piero P. Foa (center), shown here with his wife, Noomi, and Marco Nobile, is emeritus professor of physiology at Wayne State University's School of Medicine. Dr. Foa has written and edited 20 books and published many articles about medicine. He has trained many students in endocrinology and is world renown in his field. His family originated in Spain, from which they fled to Italy to escape the Inquisition in 1492. His father was a medical doctor as well as professor in medical schools in Italy and Brazil. Father and son have been active in the Dante Alighieri Society, both in Italy and the United States. Marco Nobile, from Milan, taught design at the Center for Creative Studies in Detroit. (Courtesy of Sergio De Giusti.)

Family man, business man, supporter of the arts, civic booster, and philanthropist are all terms used to describe Frank D. Stella. Born in a family of 13 children that emigrated to Pennsylvania from Guald Tadino in Umbria, Italy, Stella is a glowing example of the Renaissance man. After graduating from the University of Detroit, he entered the armed forces during World War II. Upon leaving the service, he returned to Detroit, married Martha Yetzer, and raised seven children. Pictured here are, from left to right, (seated) Daniel, Mary Ann, Marcia, Frank, and Martha; (standing) Dr. Phillip, Steven, James, and William. Stella credits the love of his family with giving him the strength to succeed in so many endeavors. (Courtesy of Frank D. Stella.)

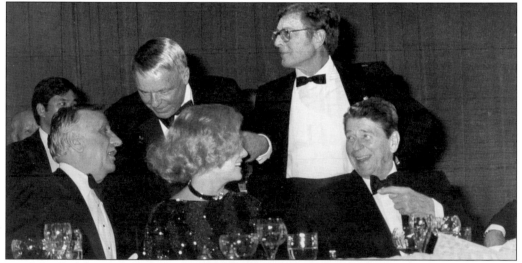

Frank Stella has received many awards, locally and nationally, including the Ellis Island Medal of Honor in 1975. His biography reads like an encyclopedia of achievements. Founder of the F. D. Stella Products Company, designers and distributors of food service and dining equipment, located on the west side of Detroit, he has served on many boards of businesses, civic, and educational organizations. He has also served in numerous capacities for the Republican Party and was chairman of the National Italian American Foundation in Washington, D.C. In recognition of his service to his community, Frank D. Stella was named Italian American of the Year in 1997. Pictured here, from left to right, is Stella with Frank Sinatra, Barbara Sinatra, Sen. Pete Domenici of New Mexico, and former president Ronald Reagan. (Courtesy of Frank D. Stella.)

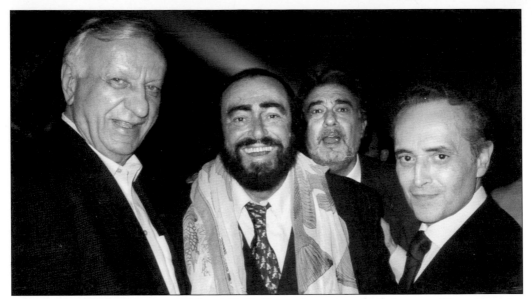

A special love of music motivated Frank D. Stella to play a pivotal role in two of Detroit's major cultural institutions: the Detroit Symphony Orchestra Hall and the Michigan Opera Theatre. In the late 1970s, Stella chaired the committee that rescued Orchestra Hall from demolition. A decade later, he became involved in the renovation of the Broadway Capital Theatre into the Detroit Opera House. Stella stated, "I want to continue to hear and feel the wonderful music yet to come. I want to see Detroit known not only as a great industrial giant, but as a city where culture and the arts coincide with business, bringing happiness to the lives of people who work here." Stella is pictured with his friend Luciano Pavarotti after a benefit concert in Detroit to raise funds for the Detroit Opera Theatre. His contributions to the improvement of life in Detroit are numerous, yet he remains a modest man who remembers well the lessons he learned from his Italian immigrant family: work hard, love God, and do what is best at all times. (Courtesy of Frank D. Stella.)

Born and raised in Detroit, Frank Angelo is another Detroit Italian who has become nationally recognized. During his lifetime, he worked for the *Detroit News* and then went to the *Detroit Free Press*. At the *Free Press*, Angelo worked his way up to managing editor from 1955 until 1971 and then was associate executive editor from 1971 to 1981. While Angelo served as managing editor, the *Free Press* won the Pulitzer Prize in journalism for its coverage of the riots of 1967. He also served as president of the Michigan Press Association in 1969. In addition, Frank Angelo has authored several books, including *Yesterday's Detroit*. He is remembered as a man of brilliance and integrity. (Courtesy of the Burton Collection, Detroit Public Library.)

Maria Stante came to Detroit from Fossa Cesia in Abruzzo in 1962. She started a business with her sons, Antonello and Mario, in 1973, Stante Excavating Company. This dynamic woman turned her talents to growing a business in construction that has flourished through the years. Equally at ease in the home as well as the boardroom, she has been successful in both. She enjoys cooking for her family, which now includes eight grandchildren, as well as cutting deals for her company. She is proud of the fact that Italian women can run for the vice presidency of the United States as well as nurture their families. This pioneer has been treasurer of the Italian American Club of Livonia for 14 years and was elected vice president of the club in 2003. She was named Woman of the Year by the Italian American Cultural Society in recognition of her many contributions to the Italian American community. Maria Stante is a splendid example of an immigrant achieving the American dream. (Courtesy of Sergio De Giusti.)

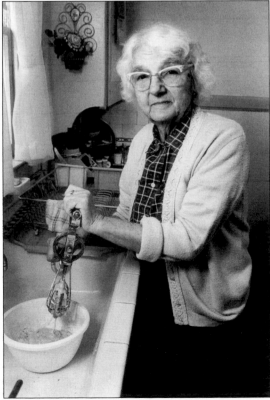

Immigrant women from the early 20th century faced especially difficult adjustments to life in America. Many were poorly educated and spoke only the dialect of their home region of Italy. Faced with raising a family under difficult conditions, they were heroic in their dedication and commitment to maintaining family life. Carmela DiCicco from Cassino emigrated to Detroit in the 1920s, raised two daughters, and managed to break the mold and go to work in a Chrysler automobile factory during World War II. Unknowingly, she was a pioneer Italian woman who successfully combined work and homemaking, and is an inspiration to her descendants. (Courtesy of Kathy Hahn.)

97

A sign of the times is the fact that Kathryn Stabile Daggy is the president of the Order of the Sons of Italy in America. Despite the title, the club is now open to women as well as men who are of Italian origin or whose spouse is of Italian descent. Kitty, as she is known, was born on the east side of Detroit and attended public schools there. She has been a school administrator for many years both in Detroit and in Madison Heights. Named "Woman of the Year" in 1998 by the Order of the Sons of Italy, she went on to become its president. She is in the center of the picture dining with friends. (Courtesy of New Era Lodge, Sons of Italy.)

Salvatore (Sam) Cosentino was born in Detroit to a Sicilian family from Enna. Growing up on the east side, he attended St. Elizabeth and St. Joseph schools. He took up the barbering trade in the 1940s. Working in the Concourse Barber Shop in the Fisher Building, he eventually bought the shop in 1958. He is the young man in the center along the mirrors with the dark hair. The shop prospered until he sold it in 1968 to move to Birmingham where he opened the Merrilwood Barber Shop that continues to serve Detroiters from all across the metro area. Sam and his wife, Nancy, raised their four children in Allen Park. Sam Cosentino has served as a member of many Italian organizations over the years, including several years as the president of the Downriver Italian American Club in Wyandotte. (Courtesy of Sam Cosentino.)

Born in Vasto in the Abruzzo, Paul Cicchini's father called him to America in 1940 just as World War II raged across Europe. He managed to get on the last ocean liner, the *Rex*, to leave Italy for the United States. A teenager at the time, he attended night school at Southwestern High School while working for a cleaner as a tailor in the Oakwood neighborhood. He was drafted during the war and sent to Europe, where he fought at Utah Beach in Normandy and then in the Battle of the Bulge. Prior to seeing action in Normandy, he was granted American citizenship while in England. When not seeing action at the front, he served as a translator, working with Italian prisoners of war and the French. Marrying his French sweetheart, Yvonne, he returned to Detroit, where they began their family of four children, Paul, Diane, Robert, and Perry, and he began to build his business.

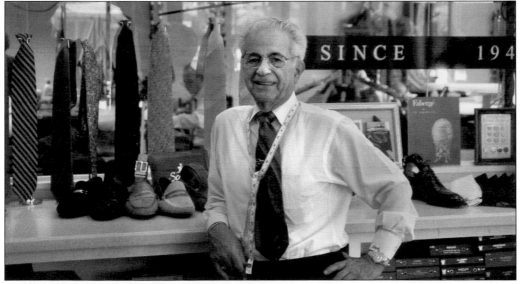

Paul Cicchini is a prime example of the immigrant success story. Arriving in America with a cardboard suitcase in 1940, he went on to become a successful businessman and family man. He credits his Italian heritage with giving him the strength and motivation to become a devoted husband and father as well as a success in business. He became a member of organizations such as the Kiwanis and the Lions Club, rising to leadership positions in them and representing Italian immigrants in the mainstream of America. He has been a member of many Italian organizations as well, contributing to the strengthening of Italian culture in Detroit and in America.

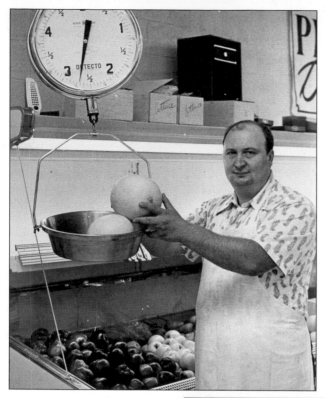

The families of Mario Fallone and his wife, Pat, came to America after World War II from Olivella in the province of Frosinone. After their marriage in the early 1960s, they opened a market selling Italian products on the northwest side of Detroit. In 1975, they followed the migration of Italian Americans west to Livonia, where they have operated Cantoro Market, providing food and wine to the many Italians that live in the north and western suburbs. People from as far away as Brighton and Birmingham come to stock up on bread, lunchmeat, cheese, and other products from Italy. Pictured here is Mario Fallone shortly after the move to Livonia. (Courtesy of Mario and Pat Fallone.)

The entrepreneurial spirit among Italians is strong. In 1953, Antonio Laudazio, a native of Cassino in central Italy, quit his job at Ford Motor Company to open a restaurant featuring pizza, a food item that was until then not well known in the American community. His timing was excellent and, with his wife, Mary, and his three children, Tony Jr., Diane, and Peter, the Bel Cassino Pizzeria became an east side success. The family-run restaurant expanded into St. Clair Shores on Harper and continued to draw east-siders for many years.

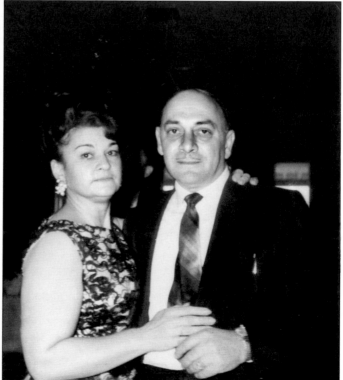

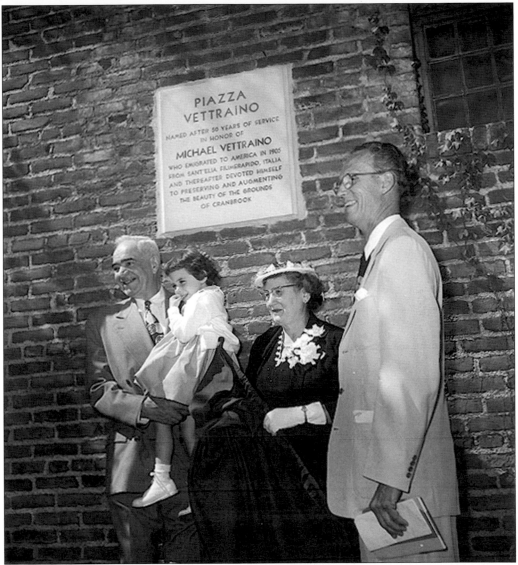

Charged to "do good for 50 years hence," Michele Vettraino was put in charge of the grounds keeping at Cranbrook Foundation in Bloomfield Hills by George Booth in 1905, shortly after he arrived from Sant'Elia, Italy. In this picture, from left to right, Vettraino, his granddaughter Michela, and his wife, Cecilia, stand next to Henry Scripps Booth at the dedication of Piazza Vettraino on the Cranbrook campus in honor of a job well done. Italian consul Antonio Carloni summed the sentiment up perfectly with his words, "In this modest Italo-American laborer I see the typical worker who contributed so much to this country—who created the bond between our two countries. Congratulations to him for the credit and respect he has brought on himself and those many who adopted this great republic as their new homeland." (Copyright Cranbrook Archives, Harvey Croze, photographer, FD27-6.)

Vincenzo Giuliano came to the United States from Calabria after finishing his military service in Italy. After a number of jobs in other cities, he was asked by members of the Italian community to start a newspaper in Detroit. In 1909, he started a newspaper in Detroit called *La Tribuna Italiana del Michigan*, now known as the *Italian Tribune*. Giuliano was the publisher and editor while his wife, Maria Oliva Giuliano, was the star reporter. In addition to running the newspaper, he was very involved in promoting the welfare of his fellow immigrants by encouraging them to become involved in American society, promoting charity, and initiating the gift of the statue of Christopher Columbus to the City of Detroit that sits at Jefferson Avenue and Randolph Street. The newspaper still serves the community today under the direction of the fourth generation of his family. (Courtesy of the Italian Tribune.)

Italians in Michigan have become involved in government at every level—local, state, and federal. There are currently six Italian Americans serving in the Michigan State Legislature, representing both major political parties. Gino Polidori, a Democrat, represents part of western Wayne County, including his hometown of Dearborn. Elected for two consecutive terms to the Dearborn City Council, he was Dearborn's fire chief for 22 years, retiring in 1996. Born in Dearborn, he is the son of immigrants from Castro dei Volsci in Frosinone, Italy. A graduate of Fordson High School, Polidori received his bachelor's degree from Wayne State University. He has been involved in many community organizations, as a member and as an officer, including the Italian American Fraternal Club in Dearborn. He shares the podium here with Michigan's governor Jennifer Grandholm. (Courtesy of Gino Polidori.)

The Honorable Robert A. Ficano, the chief executive officer of Wayne County, has had a long career in public service. His father, Antonio, was born in Sicily and his mother, Lina, was born in Detroit to immigrants from Galiano in the Abruzzi Region. He credits his dedication to public service to the values his parents instilled in him. He grew up in Livonia and graduated from Michigan State University and the University of Detroit Law School. Robert Ficano has been assistant city attorney in Westland and was elected Wayne County sheriff in 1984. He has been Wayne County executive since January 2003. He was selected as one of the Italian Americans of the Year in 2005 by the Italian American Club of Livonia. (Courtesy of Robert Ficano.)

Representative Frank Accavitti Jr. has a history of involvement in government. Since graduating from Fraser High School in 1975 and attending Western Michigan and Wayne State Universities, he was a small business owner for 20 years. Before being elected to the Michigan State legislature, he served as planning commissioner, city councilman, and mayor of the City of Eastpointe. In the legislature, he serves on the Energy and Technology Committee, where he is vice chair, the Commerce Committee, and the Local Government and Urban Policy Committee. He is a third-generation Italian American who has been raised to serve his family and community. He and his wife, Mary Elizabeth, reside in Eastpointe with their three children, Amy, Jennifer and Frank III. (Courtesy of Frank Accavitti.)

As the son of a 42-year employee of the City of Dearborn, Michael A. Guido has always been involved in his hometown. Born to Italian immigrants, he attended Dearborn public schools, Wayne State University, and the Kennedy School of Government at Harvard University. At age 23, he became the youngest member ever elected to the Dearborn City Council. He then went on to become the youngest mayor of Dearborn in January 1986. In 2001, the Michigan Municipal League recognized him as an honorary life member. The city of Dearborn is a wonderful example of a multiethnic community that is well run and demonstrably a great place to live. (Courtesy of Michael Guido.)

Lee Iacocca was not born or raised in Detroit, but he became a dominant figure in the automotive business, achieving worldwide recognition for his success as president of Ford Motor Company and then at the Chrysler Corporation. He is credited with saving the Chrysler Corporation from bankruptcy by engineering a federal government loan guarantee and then bringing the company back to profitability. Lee Iacocca has become an American legend. For a time in the 1980s, he was spoken of as a potential presidential candidate. Larger than life, Lee Iacocca has made Italian Americans, as well as other Detroiters, proud. (Courtesy of Vittorio Re.)

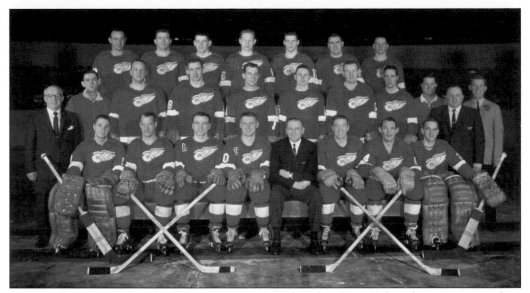

Born in what is now Thunder Bay in Ontario, Canada, Alex "Fats" Delvecchio spent more than 20 years with the Detroit Red Wings from the 1950s until the 1970s. He was an outstanding player and then became the Red Wings' coach in the mid-1970s. In 1977, he was elected to the Hockey Hall of Fame in recognition of his contributions to the game as both player and coach. Alex Delvecchio will always be a hero to those who love hockey. He is in the first row to the left of Coach Sid Abel in this 1964 team photograph. (Courtesy of the Walter P. Reuther Library, Wayne State University.)

In a newspaper career that spans three decades, Patricia Montemurri has covered nearly every subject of interest to Michigan readers. She was born in Detroit in 1957 to Mario and Nanda Montemurri, immigrants from the Italian village of Gagliano Aterno in Abruzzo. She won a scholarship for young journalists from the Rotary Foundation and studied Italian language and history at the University of Pisa. After graduation from the University of Michigan, she worked at the Associated Press in Detroit before beginning a 25-year career with the *Detroit Free Press*. She has covered everything from presidential campaigns to the pope to punk rockers. She has profiled juvenile delinquents, a community of retired Catholic nuns, a Miss America contestant with cancer, and Detroit's mayors. Her ability to speak Italian helped catapult her into the center of one of the world's most-watched events—the death of Pope John Paul II and the selection of Pope Benedict XVI. For 25 days in April 2005, she reported from Rome, interviewing cardinals, nuns who have risen to power in the male-dominated Vatican, and the pilgrims who traveled from every corner of the world. (Courtesy of Patricia Montemurri.)

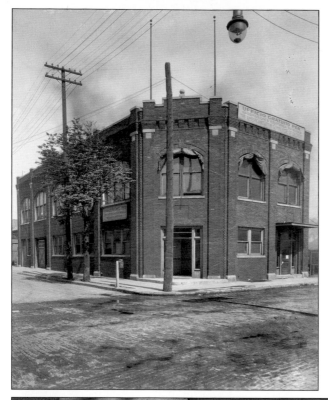

In 1921, at the encouragement of the Detroit Board of Commerce, a group of Italian businessman and professionals founded the Italian Chamber of Commerce, whose purpose was to speed up the integration of the ethnic community into the larger society by assisting in customs and transportation matters and encouraging cultural activities in the community. The building above on Riopelle Street served as its headquarters for many years. The chamber, with its 230 members, continues to serve the community from its new offices in Clinton Township. In addition to its goal of encouraging Italian businesses in the metro area, the chamber raises funds through an annual golf outing to provide scholarships to area college students of Italian descent. (Courtesy of Walter P. Reuther Library, Wayne State University.)

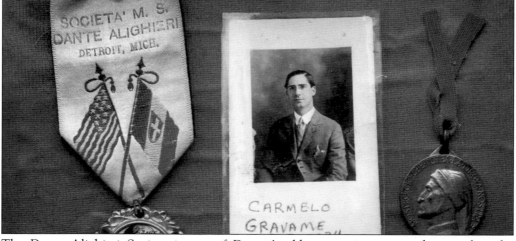

The Dante Alighieri Society is one of Detroit's oldest organizations, and its goal is the promotion of Italian culture among its members as well as in the community. It is unique among the Italian societies in that many of its members are not of Italian origin but simply admire Italian language and culture. The Detroit branch of the society was founded in the 1920s and was instrumental in supporting funding of the Dante Alighieri statue on Belle Isle. The first president was Professor Andrea de Tommasi, while Professor Piero Foa was one of the founders. Maria-Clotilde Zorzi Pfaff is the president in 2005. The society sponsors Italian language classes for children in Birmingham, and members enjoy lectures, trips to art museums, and concerts as well as get-togethers to speak Italian. The photograph is of Carmel Gravame, the first member of the Detroit branch. (Courtesy of Sergio De Giusti.)

Seven

ORGANIZATIONS

Moving to a strange country with a different culture, religion, economic system, and language is a daunting experience for anyone. During the early 20th century, it was especially difficult because communication meant letter writing and a slow transatlantic delivery. The emotional and economic support systems were far away. To the immigrant, adjustment could be very unpleasant. While the churches offered some solace, it became apparent that a vacuum existed to assist the average person in adjusting to the new experiences confronted. Thus, the clubs and organizations were organized to give support to the needy, to offer insurance for emergencies, to perpetuate the culture of the homeland, and to provide companionship.

Some organizations were formed for business reasons. The Italian Chamber of Commerce supported businesses and professionals in their service to the community. Others, like the Dante Alighieri Society, served to preserve the culture of Italy. In some cases, there were mutual aid societies to help widows, orphans, and the sick or disabled, such as the Santa Maria Lodge. Perhaps the largest number of organizations existed to bind together the sons and daughters of towns or regions of Italy. It is an encouraging sign that a large number of clubs and organizations still exist in the 21st century, run by the children and grandchildren of immigrants.

The various groups have meetings, festivals, and other activities throughout the year that bring people together to celebrate their Italian heritage and to encourage non-Italians to enjoy the celebrations with them. Italian festivals have remained very popular in the region. Many communities have ethnic festivals that include a number of national groups that share the fun and encourage diversity in American society. In addition, there are parades and dances that celebrate Columbus Day and other holidays throughout the year.

The Italian clubs and organizations play an important role in preserving the heritage of the past and in encouraging young people to have pride in their origins. In many ways, they are the hope of the Italian American future. At the present time, an umbrella organization serves to bring groups together to cooperate in showcasing Italian culture and in encouraging Italian Americans to honor their ancestry. That organization is the Italian American Cultural Society, which has recently moved into its new quarters in Clinton Township.

The American Italian Professional and Business Women's Club was established by Maria Lalli, seen here, and Maria Giuliani, co-founder of the *Italian Tribune* newspaper, in 1956 to further cultural, charitable, and social activities that would extend Italian culture. The membership of the club consists of women who are of Italian descent or whose spouse is of Italian descent. AMIT, as the club is commonly known, has been involved in health care in third world countries, children and orphans at home and abroad, Italian earthquake and flood relief efforts, the arts, the Italian American Cultural Center, the Italian Heritage Room at Wayne State University, and San Francesco Church. The club has sponsored lectures and literary events related to Italian subjects or authors as well as supporting Italian artists and musicians. For many years, the club has provided social and educational activities while serving the Italian community and humanity throughout the world. (Courtesy of Burton Historical Collection, Detroit Public Library.)

The San Marino Club in Troy is unique among Italian groups in Detroit. Its origin is not Italy but the Republic of San Marino. San Marino is a tiny independent country located in central Italy, founded in 301 A.D., and reputed to be the oldest republic in the world. Nevertheless, the Sammarinesi are culturally Italian. The citizens of the small country are well represented in the Detroit area since they first arrived by way of Sandusky, Ohio, in 1903. The San Marino Social Club was formed in 1938, and their impressive clubhouse in Troy was built in 1976 to resemble the government palace in their homeland. The Sammarinesi enjoy social gatherings as well as supporting social and cultural activities in the Detroit area and back home. Ties to San Marino are encouraged, and scholarships are offered to young people to encourage them to know their heritage.

The Italian American Club of Livonia was founded to serve the large number of people moving into western Wayne County and beyond. After a Columbus Day dinner to honor Mayor Ed McNamara, a group of Italian businessmen decided they should continue to work together to organize an association that would promote Italian culture and provide a place for family life in the community. Out of this determination came the Italian American Club of Livonia. Their success is evidenced by this beautiful building built in 1994 on Five Mile Road, which is their clubhouse. It is the scene of membership meetings, family dinners, and a bocce ball court and is a center for celebrations all year long. This group serves Italians from all parts of Italy, providing a common ground for people from the Alps to Sicily. (Courtesy of Sergio De Giusti.)

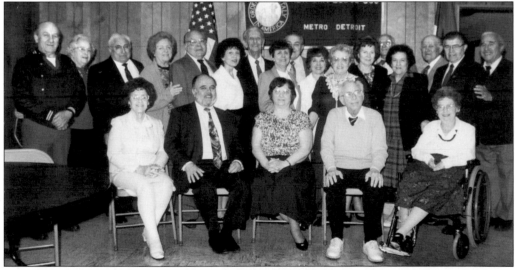

The Order Sons of Italy in America is a group of people who originated in all parts of Italy that celebrate their pride in their Italian heritage. This group's motto is "liberty, equality and fraternity," and their mission statement maintains that they exist to promote the Italian language, culture, and heritage, to provide scholarships, and to support charities. The New Era Lodge No. 126 is the Detroit branch of the national organization. Like the other organizations, it also provides a social outlet with other people of Italian origin. The organization is not, however, restricted to sons and has had several women as presidents. (Courtesy of the Order Sons of Italy in America.)

Joseph Ianni organized the Italian American Political League in Dearborn in 1921 to promote Italian participation in politics, education, and social activities. In 1948, the League merged with four other Italian clubs in Dearborn to form the Italian American Fraternal Club that is located on Oakman Boulevard. The club includes members from all regions of Italy, requiring only that the member either be of Italian descent or be married to someone who is. The attractive clubhouse shown above serves its members' social needs and is used for its members' celebrations of baptisms, confirmations, and weddings and is available for rental to others in the community. In 1976, to celebrate the bicentennial of the United States, the club had a statue of Christopher Columbus erected on Oakman Boulevard, as seen to the left, and even convinced the City of Dearborn to rename that block "Columbus Drive" in his honor.

In 1970, as the downriver suburbs were rapidly increasing in population, a group of Italians decided to organize a club for fellowship and to promote their Italian heritage. The Downriver Italian American Club was formed and today owns this imposing building on Biddle Street. The 550 members use the club for meetings and banquets and to celebrate significant holidays such as St. Joseph's Day and Columbus Day. The club marches in the city of Wyandotte's annual parade, and the members have participated in several Italian festivals in the city. Once a month, the club hosts a spaghetti dinner for the public. As with many clubs that have banquet halls, the Downriver Club rents its facility most weekends to promote the club and to help defer some of the expenses.

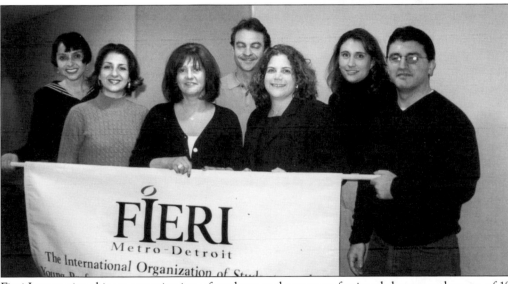

Fieri International is an organization of students and young professionals between the ages of 18 and 39 who come together to celebrate Italian culture. These young people aim to preserve the study of Italian culture and Italian American history, foster the values of higher education and personal achievement in young Italian Americans, facilitate networking and career opportunities for young professionals, and promote a positive image of Italian Americans in the mass media and popular culture. The international organization sponsors activities with educational and social purposes for its members. The club also sponsors cappuccino gatherings so its members can network. In 2005, Fieri Detroit cosponsored a trip to a Tigers baseball game with the Amici Club of Livonia. Each year, the members provide a scholarship to a high school or college student studying Italian culture or the Italian language. This scholarship is awarded at the annual dinner dance called the Festa Dell'Uva. This group smiling for the camera in 2002, from left to right, includes members Denise Franczak, Sandro DeRosa, Vivian Francini, J. Sal Canu, Anna Calmi, Jennifer Butkovich, and Anthony Agostinelli. (Courtesy of Lisa Bica Grodsky.)

111

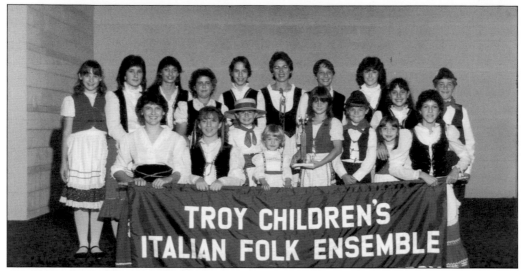

The Italian Study Group of Troy was formed by Luella Baron to promote and preserve the Italian American heritage through language lessons, culture, music, and social events. Formed in 1974, the group provides an opportunity for people in the northern suburbs to send their children to Italian language classes and to get together with Italians from all parts of Italy who want to further their appreciation of their cultural heritage. For example, I Ballerini di Troy is composed of young people who learn and perform Italian folk dances from different regions of Italy. They are under the artistic direction of Marina Cantarella-Russo and have won recognition at national and local events. (Courtesy of the Italian Study Group of Troy.)

Serving the entire metro Detroit community, the Italian Study Group of Troy has sponsored the Special Performing Arts Club, which is made up of a group of mentally challenged adults and was founded by the late Luella Baron and is currently directed by Denise Silverio. Its 25 members meet regularly with music director Karen Di Chiera and perform a play with music at their annual dinner at the Venetian Club in Madison Heights. Seen here are the performers at their 2005 event. (Courtesy of the Italian Study Group of Troy.)

The Club Conca d'Ora is a group of Sicilians from the "gold coast" of Sicily. It honors the region during a Columbus Day parade in downtown Detroit during the 1980s. As with other regional clubs, this group celebrates their pride in the province of their origin with other people who have ties to their villages and towns. (Courtesy of the Italian American Cultural Society.)

Some groups represent small towns or villages in Italy that have sent many of their residents to America. They enjoy getting together with their *paisani* and talking about the homeland. These proud people strive to preserve and pass on their ties to Italy. The town of Montelepre had a number of Detroiters who are proud of their origin and are seen here marching in the Columbus Day parade in the 1980s. (Courtesy of the Italian American Cultural Society.)

Detroit's residents of Calabrese origins also have an association, the Calabrian Club, which fulfills their need to mingle with people from their region. There are a large number of Calabrese living in the area, and they enjoy periodic gatherings, such as the dinner dance seen here. The club promotes social and cultural activities as well as promoting the Calabrese heritage. (Courtesy of the Calabria Club.)

As with the other regions of Italy, the Abrussese of the Detroit area have a strong pride in the region of their origin. The Federazione Abruzzese del Michigan was formed in 1999 and boasts 200 members that get together on a regular basis to promote the heritage of the Abruzzo in central Italy. The group sponsors meetings, dinners, and recreational and sporting activities, and promotes cultural and commercial exchanges with the Abruzzo region. This photograph is of the Memorial Day parade in 2005. Especially important are scholarships and the promotion of cultural exchanges between students at the high school and college levels. (Courtesy of Abruzzese Club.)

Pacentro, in the province of Aquila in Italy, has sent many of its sons and daughters to live in other parts of the world. Detroit has been a big center for these immigrants, and in 1968, the Pacentro Club was officially founded here with 53 charter members. Ronald D'Alesandro was the first president and presided over the first meeting at his home. The constitution states: "This organization shall seek to promote food fellowship and to encourage better social relationships between persons who have immigrated from Pacentro, Provincia Di Aquila, Italy and their descendants, to adopt and carry on an athletic program among its members, to assist its members and their families, and to perform other charitable work in the community." A summer picnic in the park is one of the activities that bond members together. (Courtesy of Club Pacentro.)

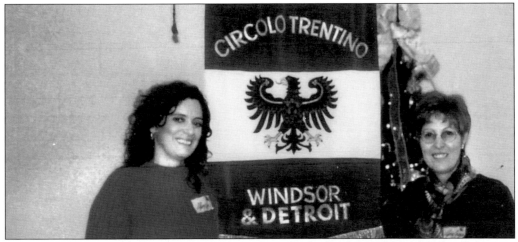

Trentino-Alto Adige is the most northerly region of Italy, bordering Switzerland and Austria. Many immigrants from this region have settled in Detroit and in Windsor, so Mariagrazia Pedri founded a club in 1986 known as Circolo Trentino of Windsor. Soon after, Carlo Chiarani of Detroit recruited Trentini in the Detroit area to join the group. With the election of Mary Jo Zanoni Schaffer as president in 2003, the name was changed to Circolo Trentino of Windsor and Detroit in recognition of the club's international makeup. The club's mission is to keep alive the traditions of their homeland and promote their heritage through support of sports activities, charitable organizations, and special events and conventions. Shown here are president Mary Jo Zanoni Schaffer (left) and former president and founder Mariagrazia Pedri with their club banner. (Courtesy of Circolo Trentino of Windsor and Detroit.)

This group photo was taken at the banquet celebrating the 50th anniversary of the founding of the Cordenons Club. Shortly after the veterans had returned home from World War II, a group of immigrants from Cordenons in the Friuli region of northern Italy decided to form an organization that would promote their hometown. For many years, this group has gotten together to celebrate Italian and American holidays with their families. As the picture indicates, the group was successful and, judging from the number of children in the first row, should be able to carry on its heritage for many years to come. (Courtesy of Cordenons Club.)

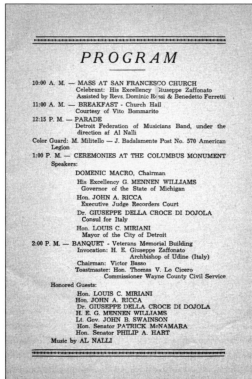

PROGRAM

10:00 A. M. — MASS AT SAN FRANCESCO CHURCH
 Celebrant: His Excellency Giuseppe Zaffonato
 Assisted by Revs. Dominic Rossi & Benedetto Ferretti

11:00 A. M. — BREAKFAST - Church Hall
 Courtesy of Vito Bommarito

12:15 P. M. — PARADE
 Detroit Federation of Musicians Band, under the
 direction af Al Nalli

Color Guard: M. Militello — J. Badalamente Post No. 570 American
 Legion

1:00 P. M. — CEREMONIES AT THE COLUMBUS MONUMENT
Speakers:
 DOMENIC MACRO, Chairman
 His Excellency G. MENNEN WILLIAMS
 Governor of the State of Michigan
 Hon. JOHN A. RICCA
 Executive Judge Recorders Court
 Dr. GIUSEPPE DELLA CROCE DI DOJOLA
 Consul for Italy
 Hon. LOUIS C. MIRIANI
 Mayor of the City of Detroit

2:00 P. M. — BANQUET - Veterans Memorial Building
 Invocation: H. E. Giuseppe Zaffonato
 Archbishop of Udine (Italy)
 Chairman: Victor Basso
 Toastmaster: Hon. Thomas V. Lo Cicero
 Commissioner Wayne County Civil Service

Honored Guests:
 Hon. LOUIS C. MIRIANI
 Hon. JOHN A. RICCA
 Dr. GIUSEPPE DELLA CROCE DI DOJOLA
 H. E. G. MENNEN WILLIAMS
 Lt. Gov. JOHN B. SWAINSON
 Hon. Senator PATRICK McNAMARA
 Hon. Senator PHILIP A. HART

Music by AL NALLI

The Columbus Day Celebration Committee has the task of organizing the annual tribute to Christopher Columbus by the Italians of Detroit. For many years, the different organizations, clubs, and societies have united through this committee to honor the great Italian explorer. Although the venues and order have changed somewhat over the years, this program from the 1960 celebration shows that the tradition is long lived. In 2005, the parade was transferred from the city of Warren to Romeo Plank Road in Clinton Township, but the participation of bands and floats representing the entire Italian American community has remained unchanged. On the Sunday closest to Columbus Day, the celebration begins with mass at Holy Family Church downtown and is followed by the placing of a wreath at the statue of Columbus on Jefferson Avenue with accompanying speeches and fanfare. (Courtesy of the Italian American Cultural Society.)

The Italian American Cultural Society was organized in 1957 with the ambitious scope of serving as a center for the community that would support all segments of the Italian American community of metro Detroit. Its mission statement is presented here. The society is a powerful voice in promoting the many aspects of Italian culture and society and in preserving its legacy for future generations. (Courtesy of the Italian American Cultural Society.)

THE MISSION OF THE ITALIAN AMERICAN CULTURAL SOCIETY

- To plan, promote, and carry on charitable, educational, and cultural activities, which will best serve the welfare of the community-at-large.

- To carry on human relations activities on a charitable basis for the purposes of eliminating bias, prejudice, or discrimination affecting all Americans.

- To encourage and disseminate and preserve traditional Italian culture by sponsoring lectures, classes, conferences, and study groups devoted to contributions, which Italians have made to world civilization.

- To counsel and assist indigent persons as a charitable basis in dealing with personal, family, or community problems by direct services or referral to appropriate agencies.

- To develop and direct an Italian Cultural and Community Center and Senior Citizens Housing Project.

The Italian American Cultural Society has served the Italians of Michigan from three locations. From the first building on Frazho Road in St. Clair Shores, the center moved to larger quarters in Warren that had formerly housed a junior high school. From this center, the group expanded its service to the Italian community by sponsoring language classes to children, meeting areas for many clubs and organizations, a chapel, a library, and a coffee shop and bar for members to relax and enjoy the company of other Italians and to watch Italian television. Senior citizen activities and many displays of Italian and Italian American history were offered. The building was used day and night by Italian groups and others who rented the facility and, thus, helped defray the costs of maintenance. In 2004, the Warren center was sold and this new spacious facility was purchased in Clinton Township, which has become the new center of Italian American population. This center is set to provide for the Italian community for many years to come.

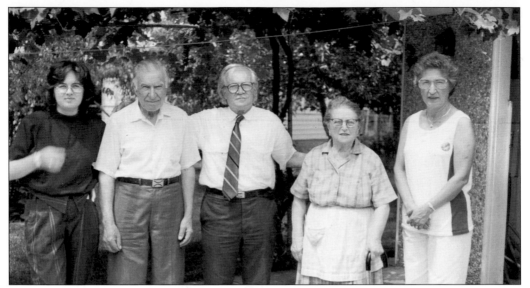

By the 1980s, modern technology had made contacts between American Italians and their families and friends in Italy easier. Air travel had become common, the telephone replaced the letter as the chief means of communication, and the rapid improvement of the Italian economy led to increased interest by Italians in visiting the outside world. The result has been renewed contacts between families. In this picture, from left to right, Paola Miele from Frosinone, Italy, visits her American great-uncle Antonio Delicato. To his right is her father, Vittorio Miele, a prominent Italian painter, Giovanna Delicato, and Rose Riopelle, an American cousin.

Reconnecting with families worked both ways. Second generation Italian Americans Lisa Delicato, center, and her brother Marco, on her right, meet their second cousins in Italy during a family visit. Candida Ruscillo is on the left, Barbara Mastronardi is to her right, and on the far right is Eduardo Caira. Visits such as this one, and the friendships that result, are one way that Italian identity is strengthened in the grandchildren of Italian immigrants.

Eight

THE FUTURE

During the 20th century, the Italian community in Detroit witnessed phenomenal growth as tens of thousands of immigrants began new lives in the New World. In most cases, poorly educated farmworkers came to America to improve their lives and to increase opportunities for their children. They were successful beyond their dreams. Their contributions have been noted in every area of human endeavor, as leaders in business, government, religion, education, the arts, and sports. Italian Detroiters have been consistently good workers, good family members, and good citizens.

As the last century came to a close, the Italian community in Detroit faced a new reality. Italy is no longer a poor, overcrowded country sending its children abroad to find sustenance. Indeed, the opposite is true. Italy is home to millions of immigrants from the third world hoping to find what their children sought a few decades ago in America. Now, Italians coming to Detroit are most likely business transfers who work in the city for multinational companies and intend to return to Europe after their tour of duty is over. The continued sprawl of the Detroit region means people tend to move farther and farther away from old centers. Intermarriage between Italians and other nationalities has become the norm, resulting in generations of people that are proud of being half or one quarter Italian. Most young people of Italian heritage are not familiar with the Italian language.

The evolution of the Italian American community in Detroit has shown that change is inevitable. The evidence shows that the community will survive even as it changes. The pride that Americans of Italian descent have in their heritage is immense. Ties to Italy have increased with affordable travel to the ancestral homeland. Genealogical interests have increased as Americans seek to get in touch with their past. Language study, especially for the young, continues to be popular. Organizations that celebrate Italian connections continue to exist and even to grow. Italian films, artists, sports figures, and political leaders are just some of the high profile people of Italian descent that inspire pride in all generations of Italian Americans. Most importantly, the family and its central role in Italian life will continue to foster a respect and love for Italian culture.

Since the first groups of immigrants began to arrive in Detroit, Italians have banded together in clubs and organizations. These groups provided comfort to the new arrivals and perpetuated their heritage. Today they still give their members a social outlet. By gathering together to celebrate holidays or just to enjoy each other's company at picnics in the summer, the members' common Italian ancestry bonds them together. People that do not speak Italian or visit Italy still can share a common love for their ancestral homeland. Here Eddy DeSantis plays Italian songs on the accordion while Maria Mariotto sings along at the Order of the Sons of Italy annual fall get-together in 1988. (Courtesy of the Order of the Sons of Italy.)

Young descendants of Italian immigrants are usually more familiar with American holiday customs than those of Italy. The Circolo Trentino makes an effort to pass the Italian customs on to their children and grandchildren. Here La Befana Floria Ferrari Sadocha gives gifts to good little children on the feast of the Epiphany. They are lucky children that have visits from Santa Claus on Christmas Eve and then are visited by La Befana 10 days later. (Courtesy of Circolo Trentino.)

BIBLIOGRAPHY

Gavrilovich, Peter, and Bill McGraw, eds. *The Detroit Almanac: 300 Years of Life in the Motor City*. Detroit: the Detroit Free Press, 2001.

Global Journeys in Metropolitan Detroit. Detroit: New Detroit, Inc., 1999.

Godzak, Roman. *Catholic Churches of Detroit*. Charleston, SC: Arcadia Publishing, 2004.

Heritage of Faith: Detroit's Religious Communities 1701-1976. Detroit: Detroit's Religious Bicentennial Task Force, 1976.

Magnaghi, Russell M. *Italians in Michigan*. East Lansing, MI: MSU Press, 2001.

Morreale, Ben, and Robert Carola. *Italian Americans: The Immigrant Experience*. Westport, CT: Lauter Levin Associates, 2000.

Patrimonio: the Legacy of Italian Art in Michigan. Detroit: Wayne State University, 1996.

Peck, William H. *The Detroit Institute of Arts, A Brief History*. Detroit: Wayne State University Press, 1991.

Pescosolido, Carl, and Pamela Gleason. *The Proud Italians: Our Great Civilizers*. Seabrook, NJ: Latium Publishing Company, 1991

Re, Vittorio. *History of the First Italian Presbyterian Church of Detroit*. Detroit: Center for Urban Studies, 1979.

———. *Michigan's Italian Community: An Historical Perspective*. Wayne State University Office of International Exchanges and Ethnic Programs: Detroit. 2003.

Vander Hill, C. Warren. *Settling the Great Lakes Frontier: Immigration to Michigan, 1837-1924*. Lansing, MI: Michigan Historical Commission, 1970.

Vinyard, Jojellen McNergney. *For Faith and Fortune*. Urbana, IL: University of Illinois Press, 1998.

Visonara, John C. "The Coming of the Italians to Detroit." *Michigan History Magazine* 2, no. 1 (January 1918).

Although the *Italian Tribune La Tribuna del Popolo* has been published since Vincent Giuliani and his wife Maria founded *La Tribuna del Michigan* in 1909, it continues to be a unifying force as it approaches its centennial. The paper is printed mostly in English, reflecting changes in the community. Providing news of clubs, people, and civic and religious functions, the newspaper is a voice for the Italian American community and provides a record of its accomplishments. A year after the paper was organized, another Italian newspaper, *La Voce del Popolo*, was created by the Catholic Church. In 1970, the two papers merged and the paper became *La Tribuna del Popolo*. When Vincent died in 1962, his wife continued as the star reporter. Their grandson, Edward Baker, took over as publisher; his wife, Marlene, entered the business as copublisher and writer. When Edward died in 2004, Marlene took over and their daughter Marilyn became executive editor. Her sister Pam is circulation manager and works in production. Four generations of the Giuliani/Baker family have had their turn running the paper. The Italian community in the Detroit area is fortunate to have this "voice of the people" providing news and a forum. (Courtesy of the Italian Tribune.)

Unlike many cities in North America, Detroit has no "Little Italy" neighborhood. There are a few remnants downtown, in the Eastern Market area, along Gratiot Avenue, and in Cacalupo to remind visitors that Italians once lived there. A new center for the Italians has developed along Garfield Road between Seventeen and Nineteen Mile Roads in Clinton Township with Italian businesses including some that have moved with the community over the years such as Bonaldi's Gift Shop. Nearby are other institutions such as San Francesco Church and the Italian American Culture Center, magnets to the now far-flung Italian community. Italians have embraced America, and America has in turn embraced Italians.

One of the many resources that the Italian American Cultural Society provides for the community is the Tivoli Manor, a senior citizen apartment house with provisions for assisted living. Located in Warren behind the former center, the apartments are available for senior citizens who no longer want to manage a home on their own. The residents have many amenities available to them that make the golden years pleasant in a familiar atmosphere. Since the Detroit area is so spread out, one of the draws is that people can share activities conveniently with others of Italian descent. (Courtesy of the Italian American Cultural Society.)

Con Il Patrocinio del
Consolato d'Italia - Detroit

Festa della Repubblica Italiana

2005
Sunday, June 5th

A Celebration of the
Fifty-Ninth Anniversary
of the Founding
of the
Italian Republic

Every year, the Italian American Cultural Society and the Italian Consulate sponsor Festa della Republica at the Cultural Center in honor of the founding of the Italian Republic following the end of World War II. It is an opportunity for American Italians to join with their Italian friends and family to celebrate the progress of the homeland. The afternoon includes entertainment, speeches, and displays by many Italian societies and organizations. It culminates, of course, in a large buffet of Italian foods and desserts. (Courtesy of the Italian American Cultural Society.)

Fostering awareness of Italian culture in Detroit is one of the Italian Consulate's goals. Consul Michele Quaroni is shown at a reception in the Detroit Institute of Arts Rivera Court for famed Italian film director Ettore Scola after the showing of one of his films. From left to right, Sandra Scamardella Timblin, Lino Scamardella, Michele Quaroni, Sergio De Giusti, and Ettore Scola pause to look at the camera. Italian culture is not reserved for Italians only, but for all people to enjoy. It is a big source of pride that so many Italians and Italian Americans have achieved international acclaim in their fields. (Courtesy of Sergio De Giusti.)

Opera is an art that originated in Italy and is often associated with that country. The Verdi Opera Theatre of Michigan was founded by Dino Valle in 1988 to promote love of opera in Michigan. In cooperation with the Italian American Cultural Society and the Italian American Club of Livonia Charitable Foundation, the theater sponsors a vocal competition among Michigan high school students. Pictured here is the program for the 11th annual concert of the finalists. The students do not need to be of Italian descent, but the program highlights Italian contributions to the world of music. (Courtesy of the Italian American Cultural Society.)

The Verdi Opera Theatre of Michigan
In Cooperation with
The Italian American Cultural Society
& The Italian American Club of Livonia
Charitable Foundation

Presents

The Eleventh Annual

"ITALIAN SONGS AND ARIAS
VOCAL COMPETITION
FOR MICHIGAN HIGH SCHOOL STUDENTS"

CONCERT OF THE FINALISTS

Sunday, May 1, 2005, 4:00P.M.

At the Italian American Cultural and Community Center in Clinton Twp.,

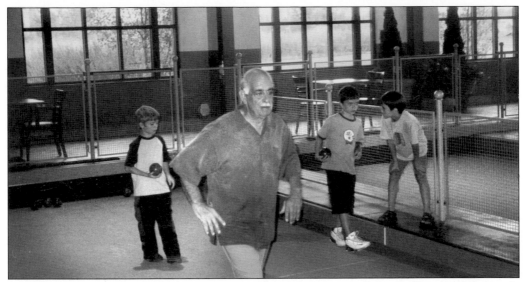

As Italian culture is absorbed into American culture, it brings its own flavors. Bocce is a distinctly Italian game but, like pizza and spaghetti, has become popular among Americans. The Palazzo di Bocce, near the Detroit Piston's Palace, is located in Orion Township, a growing community without a distinctly Italian population. It is an example of assimilation working both ways. The proprietor of the Palazzo, Tony Battaglia, provides Italian language lessons for children on Saturday mornings, followed by bocce lessons and lunch. Most of the children are not of Italian descent. A diverse cross section of Americans have flocked to join the leagues and to enjoy some time with family and friends in a pleasant atmosphere. (Courtesy of Anthony Battaglia.)

Underscoring the tremendous growth of interest in the sport of bocce in the Detroit area was the news that the Palazzo di Bocce was chosen to host the 2005 U.S. and World Bocce Championships. "Bocce is one of the world's oldest and most played sports. We're thrilled to be bringing events of this visibility and caliber to the metro Detroit area," said Tony Battaglia. Having the bocce world focusing on Detroit gives a boost to the pride of all Detroiters. Battaglia, second from the right, grew up in a Calabrese and Sicilian family on the east side of Detroit and opened the Pallazo di Bocce after retiring from his cement business. (Courtesy of Anthony Battagalia.)

There are a number of Italian festivals in the metro Detroit community each summer that feature different clubs operating booths that provide food and crafts with an Italian theme. Frances Lola (left) and Doris Messina are shown running a booth for the Order of the Sons of Italy, selling refreshments at the Italian Festival in Pontiac in 1990. While providing a good time for everyone involved and a sense of solidarity to the members, the proceeds from the sales are used to fund the club's charitable activities. (Courtesy of the Order of the Sons of Italy.)

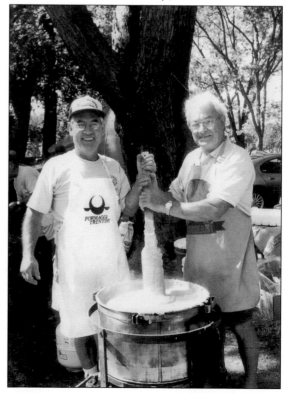

The informal atmosphere of a summer picnic or outing is a favorite activity of the many Italian clubs and organizations to recreate the atmosphere of their past as well as introduce the young American generation to the food and fun of their ancestors. The Circolo Trentino sponsors a picnic every year where participants can enjoy Trentino foods such as polenta, spezzatino, and craudi as well as more general fare. These men, Ezio Pedri on the left and Osvado Zanoni, turned the polenta so that it would be smooth and creamy. Hard work has paid off for them, as is evident in their smiles. (Courtesy of Circolo Trentino.)

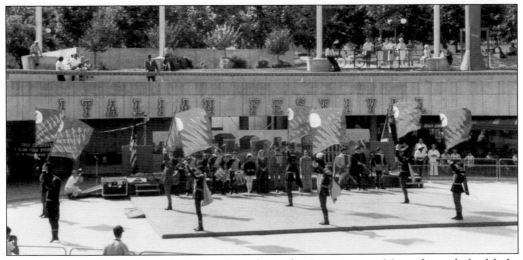

A tradition of summer festivals exists throughout the Detroit area. Many festivals highlight America's ethnic heritage by featuring booths at local festivals or through separate festivals honoring individual cultures. While the Riverfront Italian Festival no longer is held, it was a showcase for Italian culture and food for the entire metropolitan Detroit community for over 30 years. Many organizations representing different regions of Italy educated and entertained Italians and Americans alike. This photograph is of a demonstration of the flag ceremony held during the Palio in Siena. The horse race was not accommodated in Hart Plaza, however. The tradition of Italian festivals continues in Sterling Heights at Freedom Hill every summer and is very well attended. (Courtesy of the Italian Study Group of Troy.)

The Warren Department of Recreation, like those in many other communities, sponsors entertainment in the parks during the summer. The Coro Italiano from the Italian American Cultural Society entertains residents at this concert in the 1980s with their repertoire of songs from Italy and America. You do not need to be Italian to enjoy their music, but it brings about a special sense of pride for Italian Americans to know their music is appreciated by so many people. (Courtesy of the Order of the Sons of Italy.)

Little girls learn to do traditional dances such as the tarantella and perform at the Italian Study Group of Troy's annual Festa Italiana. These young people are often of only one half or one quarter Italian descent, but they are connecting with their ancestral heritage and having a lot of fun doing it. (Courtesy of the Italian Study Group of Troy.)

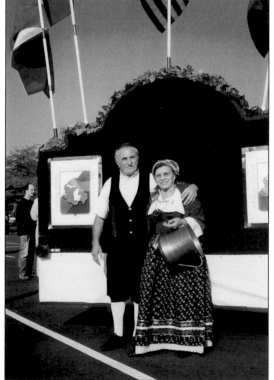

Summer festivals and parades are a fun way to remember the folkways and costumes of the ancestral villages and towns of Italy. Nucio D'Aloisio and Nunziata Salvati wear the costumes of their region in Abruzzo as part of the Abruzzese Club float in a festival parade. Participating in activities such as this one keeps Italian traditions alive for immigrants, their families, and other members of the American communities. (Courtesy of the Abruzzese Club.)